creativity

and
gratitude

creativity and gratitude

exercises and inspiration for a year of art, hope, and healing

AMY OESTREICHER

APOLLO
PUBLISHERS

CONTENTS

INTRODUCTION

SOMETIMES, THE BEST WAY TO FIND YOURSELF IS TO JUST GET LOST.

When you don't know where you're going, the world can be a scary place. That's what drives our to-do lists, our calendars, our goals, and our life plans. I know this all too well, as someone who had a minute-to-minute agenda, planning and plotting every major milestone in my life from birth to bachelor's degree to a big theatrical debut.

But occasionally, life takes a detour. Something that a yearly planner can't always account for. What's a detour? Merriam-Webster has an answer for that:

noun

1. a deviation from the direct course or the usual procedure

A detour, according to its French origins, literally means a change of direction. I, however, have my own definition of a detour: A detour is a curve in the road of life, a bump in a path, a big sign in the middle of your trip that says, "Sorry, you have to go *that* way." Nobody expects a detour to happen in life. But it's when we think we have things planned and all figured out that we're thrown a curveball.

A detour is many things—unexpected, a nuisance, difficult, hard to grapple with, and frustrating—but it can be beautiful. Sometimes, we can't appreciate how beautiful our detour was until we've made multiple twists, turns, and deviations in our set-out path. Sometimes, we can't realize the beauty of our detour until we spend a bit of time traveling it. We need to give our detour enough time to form a story of its own.

After all, every good story comes from a detour. What would be so funny about the musical *A Funny Thing Happened on the Way to the Forum* if nothing happened *on the way* to the forum? By sharing our stories, we make sense of our detours. We reframe our derailments as the intricate pathways that make up who we are today. When we tell others about our detours, we become travel partners on these journeys with no straight path. When we know we're not traveling alone, that road becomes an adventure.

Detours force us to explore new opportunities. When we can't go in the direction we anticipated, we've got to switch gears and adapt. We

have to resource inner strengths that we never knew we were capable of accessing. When we achieve the unthinkable, we discover who we really are. That's what makes a Detourist. A Detourist embraces those unexpected routes as opportunities for growth, change, and self-fulfillment. *I'm living proof that a detour can lead to unexpected blessings.*

Hi. I'm Amy— and I'm a Detourist, too. I didn't always call myself that. I was the "musical theater ham," "audacious Amy," or "the girl obsessed with the animatronics at Disneyworld." Then, my life took a turn.

The April of my high school senior year, a blood clot caused my stomach to rupture. I woke up from a coma months later to be told I

may not be able to eat or drink ever again. It turned into nearly seven years and twenty-eight surgeries. Then, the unexpected jolt of the first bite of food awakened memories of being sexually abused by a trusted mentor. For a while, this didn't seem like a journey, detour, or any kind of road to follow at all. I felt stuck—facing obstacle after pitfall, after challenge, with only a barren wasteland ahead. But I kept going—or rather, stayed on a path—*any path I could find*—until things got better. That wasn't easy. It took time to find the beauty in the twists, turns, and detours that I continue to travel. But whose life goes exactly how they plan, anyway? Straight paths are boring.

Because of my fifteen-year trauma marathon of ups and downs, I've written a one-woman musical about my life, discovered the world of mixed-media art, published plays, recorded albums, and given three TEDx Talks—all about transforming adversity into creative growth—and through my writing, speaking, and workshops, I've inspired others to navigate their own detours by turning obstacles into opportunities. What I've experienced is, the more stories we hear about turning an obstacle into an opportunity, the more empowered we are to transform our own lives and have confidence that when life *does* surprise us, we're capable of getting through anything.

Even as I continue to deal with wounds, scars, and some medical issues that haven't been resolved, I look for the upside of obstacles. I welcome the unexpected change in my "thought-out" life and see

what opportunities may arise. If I took away all of the setbacks, hurdles, frustrations, and detours, I wouldn't be who I am today. I wrote this book to share the actionable steps that helped me through all of my experiences—so that you too can love your own detours.

How can you start loving your detours? Here are six little tips on getting started:

1. Savor the element of surprise. Straight paths are boring.

2. Find one beautiful flower along the path and name it after the detour that led you to it.

3. Keep traveling to see where it leads.

4. Find a new friend along the path.

5. Use it as a chance to locate your internal compass.

6. Put the pedal to the metal and take the best road trip of your life!

Can Anyone Be an Artist?

Everyone *is* an artist! There's a classic Picasso quote, "Every child is an artist. The problem is how to remain an artist once he grows up."

You'll tackle that problem here. You don't need to know how to use a paintbrush, play the piano, or do a pirouette across a dance floor to be an artist. Creativity is a mindset—a way of seeing the world—and it's your best guide when it comes to problem-solving, traveling uncertain territory, or finding simple happiness, presence, and life.

Gandhi was right when he said, "Be the change you want to see in the world." You have the power to create the change you want to see in the world and in yourself. You don't need to be a poet, writer, or big talker to express your thoughts. This book will help you express yourself in a more honest, authentic, and satisfying way.

Creativity is not just arts and crafts. Creativity is energy! So whatever energy you may be feeling—emotions like anger, joy, sadness, or frustration—by doing the activities in this book, you'll learn how to easily convert your emotions into creative energy. And you'll feel so much better once you do. It doesn't matter *what* you write, or how *well* you paint. We all need creative outlets to get those restless colors, thoughts, and feelings out of us. I can't wait to share some tips on doing this—secrets that, frankly, saved my life.

As a survivor of severe medical trauma, creativity was my road map where there was none, my anchor when times felt uncertain, my

lifeline back to myself, and an empowering tool to feel as though I was cocreating my circumstances along with the universe.

What to Expect

For fifty-two weeks, you will be prompted to take part in a creative exercise that will teach you about the four skills for resilience: Creativity, Hope, Storytelling, and Gratitude.

The Four Skills for Resilience

1. **CREATIVITY:** You don't need to be an "artist" to be creative. It's a mindset! Through creativity, we are able to broach experiences and emotions that may be too painful, frightening, or overwhelming for words, as well as ones that have yet to be acknowledged.

2. **HOPE:** Hope doesn't just appear in a magical beam of light. Hope has to be created. But don't worry—we'll do a lot of creating in this book!

3. **STORYTELLING:** Why are stories so great? They give you a framework to make sense of your own uncharted territory. I'll share secrets from a kaleidoscopic range of

storytelling structures (filled with adventurous loopholes and hidden paths) with you—and the best part is—you will learn how to tell your story using no words at all!

4. **GRATITUDE:** Giving thanks is just for Turkey Day and obligatory thank-you notes, right? Not at all. Gratitude was my lifeline. When my life slipped upside down (and then some), and I decided to start looking for things to be grateful for, I suddenly realized what I'm about and who I am. Finding yourself is a daily process, and this book will give you creative exercises to find gratitude every day. Once you start, you won't be able to stop! Trust me, I'm still going.

By Doing the Exercises in this Book, You'll Learn

- Tools for improvisation
- Creativity as a way to see the world, and as an essential mindset
- Creativity as a way to challenge old ways of thinking
- To turn adversity into personal growth
- Methods for setting up a "Detour Day Celebration"

Tools to Get Started

🍂 A sketchbook. A sketchbook will be critical in the exercises ahead; you can find one in the form of a traditional sketchbook from an art supply store—one designed for mixed-media work or a simple sketch pad—or a notebook, such as one sold as a journal or diary, or you can do each exercise on a separate sheet of paper and collect them over time. Choose what feels right for *you*. Because you'll be exploring a bunch of exciting new skills during these fifty-two weeks, it will help to use thicker paper (thicker paper is more resilient and allows you to experiment with a variety of different artistic tools like watercolor, crayons, and glue for layering collages). You'll also find places in this book where you can write and draw directly.

🍂 Label a shoebox "Detourist Collections," and begin collecting scraps, mementos, clippings, photos, pictures, or other items that strike you and save them in it. These are extra expressive materials that can help you start creating on the page. Maybe words that you have clipped from a magazine, or photos of architecture or landscapes, or even wrappers or other things you might otherwise consider trash. There will be certain prompts in this book that you may want to incorporate some of these into. You'll be surprised by what can be turned into

art! My own working process is intuitive and instinctive. I tend to work with a lot of layering and mixed-media materials, anything from tissue paper to fabric, buttons, papers, and toilet paper—sometimes whatever I found in hospitals as I recovered. I love playing with textures, colors, and shapes and allowing them to transform sadness, joy, and gratitude. You'll learn to do the same—so don't automatically consider anything garbage or useless!

- Gesso. Here's an "artsy supply" I recommend getting: a bottle of clear gesso as well as white acrylic gesso. You can find these online, or at any art store. With this basic layer of paint, you'll be amazed at what you can create.

- Paintbrushes.

- Magazines, photos, and books that you feel okay ripping apart or playing with.

- A place in nature.

- You, your presence, and the here and now.

Remember, nobody expects a detour to happen in life. When we think we have things planned and all figured out . . . that's usually when we're thrown a curveball. Detours have created the most scenic surprises in my world. Now, I envision a world where detours in life are everyday blessings. The road is open with possibility, with voluptuous curves, and with wandering wonder.

Safe travels, Detourists!

A Note on Collecting Flowers

Along the road you will have to stretch your minds and channel the courage to see things differently. There might be some challenging moments but don't lose faith! Pay attention to what you discover, the things that surprise you and the happy accidents you encounter (did you know that potato chips were discovered by accident? And donuts?). The surprising things that catch your eye are your "flowers." These can feel as striking as a rainbow emerging from storm clouds during an afternoon walk, or as small as a bee collecting pollen. Don't prejudge the value in what you see along your journey, just be mindful to keep track of them as you go.

GETTING TO KNOW YOUR SKETCHBOOK

A sketchbook is the perfect tool to tap into your creative side and learn resilience as it provides you with a personal and portable way of documenting difficult or riddling aspects of your life, sitting with them, and working through them artistically. In your sketchbooks, you can home in on things you might otherwise overlook or take for granted, as well as organize your thoughts, and store your musings, ideas, and feelings.

Building a life based on creativity, hope, storytelling, and gratitude requires a daily practice. And checking in with your sketchbook daily allows you to freely envision your dreams and see them to fruition.

If you're intimidated by the idea of opening up a sketchbook right now, I have some tips to get you started. Don't worry about the words "drawing" or "sketching." Drawing is another way to observe and listen, rather than through seeing and hearing alone. There's no pressure to produce a perfect drawing in a sketchbook.

You don't need to call yourself an artist to call your notebook, journal, or drawing pad a "sketchbook." This is your place—a place for your discovery and enjoyment, where you can develop ideas, experiment, explore, and discover new ways of listening, observing, and being—all while drawing and journaling. This is a safe place—a place where you can make mistakes without feeling that you've failed. It can be tempting to buy blank notebooks with pretty covers and inspirational quotes, but we may never use them if we have barriers preventing us from truly engaging with them—and our inner feelings. A sketchbook only earns its title if you use it.

Why should you keep a sketchbook? Memorializing things in a sketchbook is a way of making the ordinary significant. For me, it feels great to know that all of my thoughts and doodles are in one place. I have various sketchbooks both from before my coma and afterward. It's touching to see my old handwriting as a teenager, my scribbles of outfits I wanted to wear the first day of school, and even sketches of prokaryotic cells I'd copy from my biology notebook. These are memories of my pre-coma life that I'll cherish forever.

When I flip through my old sketchbooks, I can see how I eventually found my voice after my coma. First, my lines were shaky as I struggled with learning how to move again. Then, I drew pages and pages of drinks I couldn't wait to gulp, slurp, and guzzle on that magical day when I would have my first sip of one again. Then, there are rubbings of leaves I've collected on my walks; rounds of Scattergories I played with my mom to pass the time; and various thoughts, shapes, and blank pages.

Just as marathon runners train by working out each day before a big race, you'll grow your creative muscles by honoring a daily practice with your sketchbook. Soon, you too will be able to chart your growth, fears, and ambitions by the doodles, scribbles, and sketches that lie within. A sketchbook will help you approach everything with a sense of curiosity. And if you're curious about the world around you, you'll be pulled to constantly explore your circumstances and discover how you can improve upon them.

Making It Yours

The most important thing about your sketchbook is that it should feel like it's completely yours—a safe and treasured place where you can express your whims, wants, and worries without judgment from others—or yourself. What's important is that you draw in it every day—even if you just make a single mark!

A sketchbook can be any size. It can have lines or not. It can be spiral-bound, a flip-book, a Moleskine, or even pages of an old newspaper stapled together. Do you need to reread that? Yes, I mean it. You can use newspaper or a used novel as your sketchbook. It's a creative process in itself to prime the pages. "Prime" means to cover the old pages sufficiently so that you have space to make your own marks. Here are a few ways to prime a page:

- Tape blank sheets of paper over the old pages.

- Use masking tape or duct tape to cover the old pages. If you do this, you will have to use a Sharpie as your drawing and writing utensil.

- Paint the pages with white acrylic gesso. White gesso will prime the pages so that you can use any drawing utensil on them.

When you are selecting a sketchbook, look for something that feels comfortable in your hands and fits into your bag, so you can take it with you on the go.

Feel free to use the sketchbook for anything you want: making marks, drawing what's in front of you, doodling geometric shapes or words, sketching scenes from books you are reading or memories that play in your head, or even pasting in photos and materials. Don't wait to be inspired, just make a mark every day and set a time-goal for

completing the sketchbook. For example, you might try to complete a sketchbook every six months.

Design the Cover of Your Sketchbook

Start collecting images, words, pictures from magazines, or things that give you hope and paste them on the cover of your sketchbook. You can start forming a vision of how you'd like your path to go. What's in the clearing? Any words, images, and designs that strike you, belong there—and the less thought you put into it, the better!

Blank Page Syndrome

Diving into a blank sketchbook can be scary. When I first started journaling, I realized that to get past that intimidating blank page moment, I had to get past all of the thoughts going around in my brain—not only years of trauma, but the anxieties about what I should do with those memories. Remember, no one else needs to ever see your sketchbook. *You* don't even have to look at a page again once you've flipped to the next one. On the next few pages are some tips that helped me get started.

Meditative Doodling

I find that play is the best remedy for blank page syndrome. Are there certain shapes that you enjoy? My favorite shapes include hearts, teardrops, and lightning bolts. These are symbols I doodle again and again because they feel good to outline. They don't have to be perfect, you are just doing what feels good and putting marks down on paper. Now, decide what your favorite go-to shapes are. Stars? Trees? Peace signs? Squiggles? What feels right? Maybe fill in the shapes. You could add little smiley faces in your peace signs. Arms on your lightning bolts! This is what makes this your sketchbook—you're putting your personal mark down. So go ahead. Make your mark!

One of the best things about doodling is that it's a naturally meditative activity; because doodling involves repetitive movements, it forces you into a calming flow that is more concerned with being present than analytical thought. Once you've repeated a shape enough times, your brain takes a backseat and is quiet enough that you can listen to your gut. This is how to make doodling a meditation. And as you meditate, it's a great way to let your hopes, dreams, and confidence bubble to the surface.

Keeping Up a Detourist Collections Box

Don't forget to keep replenishing your Detourist Collections shoebox (page 15), being mindful to collect things that inspire you. Every now and then, look over what you've collected. What do these items say about you, your inspirations, and your hopes?

When you are ready to use the collage bits, tape them into your sketchbook and let that be the generation point from which to start a doodle. Let your pencil or marker wander and let yourself be surprised by the things that come out. I love saving fortune cookie messages in a collage bits envelope within my box, and pasting them into my sketchbook so that I can use them as a jumping-off point to sketch out my dreams of what's to come.

Art to Go

The best thing about a sketchbook is its portability. When you are armed with a sketchbook and a pencil, you have everything you need to create a sense of creativity, gratitude, and hopefulness. Just turn off your phone, find a place outside, and observe the life around you. Look around for signs of possibility: flowers blooming, children playing, neighbors helping one another. Take in the sights, smells, and sounds, and express them on your pages.

Logic will get you from A to B. Imagination will take you everywhere.

—ALBERT EINSTEIN

creativity

Creativity as a way of life is about flexibility, spontaneity, evolution, growth, change, and embracing uncertainty. Creativity is a lifelong journey with no required destinations, but with little beautiful lookout stops along the way if you take the time to find them. Creativity is a mindset that allows us to see possibility, to find flowers, in what may have seemed barren ground before.

This possibility is the greatest part about being alive. We have countless blank canvases before us. Creativity provides us with the ability to give back, and allows our work to serve as a lens, mirror, or window that others can look through, or look into, and see themselves and feel whatever they need to feel at that moment. It helps us to connect with ourselves and one another.

Art is how I connect with my world—how I summon my *aliveness*. As a member of the human race, it is how I can contribute. We all want to make our mark on the world, to cause a ripple, maybe even a chain reaction. Art empowers us with the ability to create a ripple of

happiness. As humans who can make art, we have the power to use it to help make every moment important. Even the smallest of gestures—a random act of kindness, a tender word, a brushstroke—can make positive changes. How will you make your mark on the world?

WEEK 1

EMOTIONS

When I was first discharged from the hospital after my stomach ruptured, I felt swarmed by emotions and I didn't know what to make of them. I was shocked and saddened that I could never get my old, unwounded body back. But what really startled me was realizing what had happened to my mind. Not only had I woken up in a new body, but I also now had a mind troubled with fear, uncertainty, sadness, and anger, and any feeling might trigger another hunger. With no digestive system, hunger was off-limits. Food was fatal. So numbness became my best friend to keep me alive.

While I was working to gain back my physical health, I was unprepared for the flashbacks, images, and memories of scary events that I

thought I had repressed. Whenever I started to experience these, I felt like I had to avoid any stimulant that might make me feel anything at all. Nothing felt safe. I lived my life like I was constantly running or fleeing. When I was unable to eat, this was a survival mechanism; I believed that if I allowed myself to feel, I might actually feel the deadliest sensation of all—hunger. By the time my digestive system was finally reconstructed, I was so used to avoiding my emotions that feeling anything at all was a tremendous struggle for me. I had grown accustomed to staying numb. It was too painful to remember every setback and struggle, too overwhelming to recall everything I had lost with every surgery.

Becoming numb made my world a blurry haze. It was also counterproductive. I became extremely anxious and irritable. If I couldn't constantly fidget or find another way to "numb out," I would start to panic and be overwhelmed by even more intrusive memories and raw, forgotten emotions.

Soon, even as I tried to drown them out, emotions were controlling my life. But when I learned not to label emotions as "fear," "anger," or "anxiety" and to embrace them as sensations, my world changed into an exciting playground. I can't wait to share that world with you.

When we get hung up on labeling our emotions, we can get stuck in our heads. Whether it's sadness, frustration, or anger, if we hyperfocus on naming, identifying, and battling how we feel, we might have

trouble moving forward. But if we embrace emotions as energy—fluid and shifting—we can act like artists and transform our feelings into something new.

If we engage a creative mindset, we can unstick ourselves and change how we experience what is happening to us. Using the power of visualization, we can connect with our bodies and use our physical sensations as guides to our inner emotional journeys. When we engage with our sensory experiences, we check in with how our bodies are feeling and responding to stimuli, leaving us receptive to inspiration and creativity.

Sensation Language

Sensation language describes physical feelings using words based on the five senses: taste, touch, smell, sound, and sight.

It is important not to confuse sensations with emotions. While emotions *do* have accompanying sensations, emotions themselves are not sensations. Some examples of sensation vocabulary are cold, warm, light, heavy, tender, wooden, achy, tense, shivery, calm, floating, flowing, expansive, tired, and buzzed.

Practicing Sensation Language

Here's an example of a thought that is stuck in the pattern of labeling emotions: *Ugh! I am so angry. It feels awful!* Let's translate this thought

using sensation language to describe our feelings: *I feel a hot red ball thread knotted in my chest.* If we focus on the sensations that anger invokes, rather than hyperfocusing on the emotion itself, we can get unstuck.

Now, write down a sentence of your own that states how you are feeling:

Translate that sentence using sensation language:

In the space below, scribble your sensations:

Emotions and Sensations

Imagine yourself in each of the following scenarios. In the space beside each situation, write down the first emotion that comes to mind.

You've been fired: _____ _____

You've watched a sad movie: _____

You see a cute dog on a walk: _____

You're waiting to meet a long-lost friend at the airport:

You're stuck in rush hour traffic on the way to an important meeting:

You're at the highest point of a roller coaster and about to take the plunge:

You're getting ready for a first date: _____

You're writing to a favorite relative
who has recently moved to another state: _____

Now, again, imagine yourself in each of the above scenarios, this time focusing on your bodily experience. What colors do you see? Are you warm or cold? Do you feel limber, wound-up, or tense? In the space beside each situation, use sensation language to describe what you experience.

Translating Feeling

This week keep tabs on your emotions: How are you feeling? Every day this week, jot down your emotions, as well as what you see, smell, taste, touch, and hear as you feel them. Finally, using sensation language, translate your emotion into a sensation. Do you notice any patterns? Does paying attention to your sensory experience shift how you feel? Do your emotions—negative or positive— color the intensity or sensitivity of your bodily sensations?

Monday

Emotion: _____

Sight: _____

Scent: _____

Taste: _____

Touch: _____

Sound: _____

Sensation: _____

Tuesday

Emotion: _____

Sight: _____

Scent: _____

Taste: _____

Touch: _____

Sound: _____

Sensation: _____

Wednesday

Emotion: _____

Sight: _____

Scent: _____

Taste: _____

Touch: _____

Sound: _____

Sensation: _____

Thursday

Emotion: _____

Sight: _____

Scent: _____

Taste: _____

Touch: _____

Sound: _____

Sensation: _____

Friday

Emotion: _____

Sight: _____

Scent: _____

Taste: _____

Touch: _____

Sound: _____

Sensation: _____

Saturday

Emotion: _____

Sight: _____

Scent: _____

Taste: _____

Touch: _____

Sound: _____

Sensation: _____

Sunday

Emotion: _____

Sight: _____

Scent: _____

Taste: _____

Touch: _____

Sound: _____

Sensation: _____

WEEK 2

CREATIVITY AS A MINDSET

If you don't call yourself an artist, per se, how do you know when, what, and how to create? Sometimes the best creative inspiration is having a problem to solve. To solve a problem, you have to see things from different angles and points of view and doing so requires creativity.

One of the biggest problems plaguing many of us is boredom. I'm not just talking about commercial breaks, a meeting at work that never ends, or traffic light kind of boredom, but the existential sense of sameness and routine that pervades everyday life.

As a kid, I always used to complain to my older brother, "I'm bored!" Even when I was little, I was always darting about from activity

to activity. My mind was racing, and I was antsy with ideas.

His response was always the same, "Why are you bored?"

I didn't know.

I'll never forget what he gave me as a birthday present that year. His card was a simple little handwritten Post-it that read, "This is so you'll never be bored again."

I opened his present, hoping it was some kind of toy or exciting little gadget. But it was a softcover activity book for me to fill in. I felt that natural letdown that happens when you get your hopes up and just get . . . a book. *No! Not a book!* But then I looked at the cover which read, *Things I Can Be Happy About.* It was a workbook filled with blank, numbered lines, broken up into categories like "Outside," "School," "Friends," and "Activities."

My brother was trying to teach me my first lesson in creativity and gratitude. If you take stock of what you can be happy about and start putting pen to paper, it's hard to ever get bored. A lot of times when we're bored, we're just stuck: unhappy and inactive. A creative mindset invites us to see our circumstances through a fresh lens so that we can be present, inspired, empowered, and—dare I say it—happy.

This week I invite you to see things differently. To choose wonder over boredom. All it takes is a little mind-bending. We're never too old to create fantasies. When we elevate the everyday, we can't get bored. We're struck by every laughing tree, every popping color, every breath

of sunrise. And even better, whimsical fascination with the world around us might inspire us to create . . . and with a project or an idea in our head, how could we ever get bored?

Creativity: Not Just for Artists

Start by looking at a simple object in front of you, for example, a bottlecap. Sit down, breathe deeply, and examine each ridge, each curve, each tiny molecule of texture. Feel it in your hands and think about its function. If you are investigating a bottle cap, ask yourself, *What bottle am I opening?* You could be opening a potion bottle, releasing a genie trapped inside, or unlocking your creative spirits. Maybe you spot a paperclip at your desk—what special powers does it hold? What top secret documents or pile of love letters has it held together?

In the space on the next page, draw a sketch of your object coming alive and participating in a function that is sacred to you. Think about how it has enriched your life. The more you give in to the details, the more delicious the exercise will become for you—so think about your object for a while to truly open those creative doors.

WEEK 3

AWARENESS
WITHOUT JUDGMENT

ALL TRUE ARTISTS, WHETHER THEY KNOW IT OR NOT, CREATE FROM A PLACE OF NO-MIND, FROM INNER STILLNESS. —ECKHART TOLLE

Let's start with focusing on awareness without judgment. How can we view something we may be used to seeing every day with new eyes, or a beginner's mind? Sometimes we judge things as hard, scary, or too overwhelming before seeing them as they really are, objectively. Let's say I were to ask you to draw a still life of what you see in front of you, for example, a bowl of fruit. You might think, *What? I'm not an artist—I've never even taken a sketching course. How do I show dimension, texture? I'm doing it wrong!*

Our brains judge things as good or bad, right or wrong so rapidly that they can easily scare us out of even trying. Practicing awareness without judgment—pausing, breathing, and seeing with an open mind—allows us to appreciate those little moments and ordinary objects without nerves and doubt.

Dr. Jon Kabat-Zinn of the Stress Reduction Clinic and the Center for Mindfulness in Medicine, Health Care, and Society at the University of Massachusetts Medical School says that "mindfulness means paying attention in a particular way: on purpose, in the present moment, and nonjudgmentally."[1] By utilizing the powers of observation and getting to know our five senses, we can see things unemotionally, just as they are. And when we see things without predetermined words, titles, feelings, or associations, we can approach them with minds that are blank canvases, free from any blocks that prevent us from creating.

Get to Know Your Heroes

I think of my five senses as my Superhero Five Senses because they save me in the nick of time when I'm about to get lost in anxious thoughts. When I start worrying or pitying myself, I call on my senses to ground me before I get swept away in thought.

1 Jon Kabat-Zinn, "Mindfulness Attitudes Letting Go," Mindfulness Based Stress Reduction, April 23, 2020, https://mbsrtraining.com/mindfulness-attitude-letting-go/.

In the space below, sketch each of your senses as a superhero. Give each of the five senses its own personality, name, and unique attributes. Imagine them following you wherever you go. You'll need them to remind you to be present in your body whenever negative thoughts take over.

See Things Differently

This week, head out on a walk, choosing a route you take on a routine basis. You might see the same things that you usually do or pass by the same old landmarks, but this time will be different. With your Five Superhero Senses and your sketchbook by your side, consider the following prompts:

1. View the world as an artist studying a scene to paint a picture from. Write about the colors, shapes, and lines that you see and the brushstrokes you will use.

2. Imagine every object is alive and talking to you. What would they say?

3. How am I like the objects I see before me? Write about the similarities.

4. Look for the human face in everything. Write about a tree (or car) that comes to life.

5. Be curious: Ask childlike questions about the world around you. What makes the sky blue or the clouds fluffy? Answer your questions.

WEEK 4

INSIDE OUT

A t a time when most of my friends were graduating college, I was being discharged from the ICU after dozens of surgeries, and without a stomach. Medically stable, but emotionally drained, I yearned for some way to replenish my spirit and to rediscover a sense of self.

Since IV wires, feeding tubes, and daily nurse visits were still big parts of my life, I wasn't ready to go away to college, so I took a job as an aide for three- and four-year-old children at a local nursery school. Almost instantly, they helped me become fully present and find magic in the simplest things.

One day, I brought plastic spoons and a jar of dried rice to class for the children to play with—a toy without any bells and whistles! For

the next twenty minutes, the children were giddy, riding the waves of their imaginations. One child dug her spoon into the rice, hunting for treasure, another child went scuba diving, and another built a dinosaur from the tiny grains of rice. Can you imagine limitless possibilities for an ordinary object?

Watching my nursery school children make rice-scooping decisions, build playful relationships, make creative discoveries, and laugh at beautiful mistakes, I gained confidence in my own life circumstances. More importantly, I learned that happiness is not such a lofty ambition. It is as available to me as the nearest package of dried rice at the grocery store. As I continued to be challenged with medical hurdles and milestones that seemed beyond my capabilities, I found imaginative ways to face my struggles head-on. Surviving and thriving can be aided by child's play, and this exercise helped me practice that.

Step One

Select an object in your home that you use every day: a coffee mug, a doorknob, a clothes hanger. (Try to limit yourself to objects without screens—we could all use a break from phones, TVs, and technology once in a while.)

Step Two

After you select your object, find something blank, or clear, and stare at it for a few moments. This could be a blank piece of paper, your kitchen floors, or a white wall. Next, think of a color. Take a deep breath in, and as you exhale, imagine that your breath is filling your body with that color. With every exhale, breathe out words and thoughts. Keep going until words and language are cleared from your system and you are only filled with color.

What's that color? Don't name it! Fill in the box on the next page with that color. Don't worry if you don't have a colored pencil or marker on hand. You can complete this exercise with a regular pen or pencil. Remember: creativity is about seeing things differently. Using your imagination, represent your color in the intensity of your lines, the shapes you create, and the way that your hand dances across the page.

Now, let's try seeing things differently with the everyday object you selected in Step One. Sit in front of your object, having breathed all words and language out of your system. Pretend you've never used that object before. You don't know what it does. What else could it be? Write down the first five ideas that come to your mind.

1. _____

2. _____

3. _____

4. _____

5. _____

Now draw the object, not focusing on its use, but its outline. Focus on which lines are straight, curvy, squiggly, or broken off. Try to detach the use of the object from how it appears. In doing so, we can set aside preconceived notions of what the object *is* and clear space in our minds to imagine what else it *could* be, giving it limitless capabilities.

WEEK 5

IMAGINATION

Embracing creativity allows us to bring our imagination with us into adulthood. When I awoke from my coma, I was told that I no longer had a stomach and it was not known when or if I'd be able to eat or drink again. I took my life as it came day by day—but it took a grand total of over four years and twenty-seven surgeries to inventively—and quite creatively—construct a mini-digestive system for me with whatever intestine I had left. My insides have often been compared to a terribly tangled mess of over-boiled spaghetti.

So how did I survive over four years (besides IV nutrition, which was *not* as satisfying as a huge bowl of ice cream) without even a tiny ice cube to satiate myself? I had to be *resourceful.* This is what creativity

means to me: being resourceful by tapping into the possibilities of our imagination.

I made up my mind that I would label myself as "sick," a "victim," a "patient," or a "has-been." I would not be passive in the face of a crazy situation; the world would *not* leave me behind. I would never ask *why me?* or be filled with anger, resentment, useless worry and wondering, pity parties, and the like. As a musical theater actress since childhood, I was still intent on making my mark on the world—making a difference in my community, and nurturing my own soul with the beauty of art in all of its many shapes, forms, and sizes.

Every day I taught at the preschool brought a new life lesson. One morning, an adorable three-year-old, Isabelle, was sitting tucked inside her cubby, staring down at the floor with her ankles crossed.

"What's wrong?" I asked her.

She replied, "I'm very sad today."

When I asked why, she said, "I can't think of any Star Wars adventures to dream about so I don't know what I am going to make-believe today!"

I was touched by how Isabelle depended on the safe haven of her fantasies to pass the time; the adventures in her mind were the highlight of her day, and if she couldn't find those dreams in her that day, then the day was lost. I was almost envious of how she clung to that importance, and it made me wish that I could play in the vivid world of imagination rather than fret over medical circumstances beyond

my control. I realized I needed to find my dreams, like Isabelle had. Then, how could I be sad?

Imagination for Creation

Define imagination in your own words. Brainstorm ways to activate your imagination. What are the books, movies, art, or other things you've read, watched, listened to, or experienced that have inspired you to get into a creative headspace—to daydream and think beyond practical and conventional limitations? Write them down here:

Books: _____

Movies: _____

Art: _____

Music: _____

Fill Your Head

Opening your sketchbook to a blank page, take a pen or pencil and draw a large outline of your head. Remember, the drawing doesn't have to be perfect, just make sure that you feel that it represents you. Next, find some magazines, catalogs, or old photos in your house. Using scissors, cut out images and words that inspire you or stir you. With tape or glue, secure the images within the outline of your head.

After twenty minutes, take a look at the collage you've created. How do those images fuel your imagination? What do they make you dream of or hope for? Jot down your thoughts here.

WEEK 6

SKETCHING FROM MAGAZINES

All that this week's exercise requires is some tape, four random corners of any pictures—even snack labels or whatever is lying around—and the willingness to see something with new eyes. I used to do this daily in my sketchbook.

Find some magazines or catalogs around your house and flip through the pages, ripping out any images that strike you until you have four. (Don't stress too much about what you pick, but aim for images with clear outlines and simple depictions.)

Next, cut a two-inch by two-inch square out of each image (it doesn't have to be exact), trying to capture an interesting point, shape, or edge.

Place all four random images in a square, so all sides are touching.

Now, with an objective eye and awareness without judgment, put your interpretation of the image you've created on paper. In the box below, sketch the image with a favorite crayon or pen. Once you've completed your sketch take a step back and try to see this image as a completely new creation from the four pieces you've put together.

WEEK 7

TURNING THE WORLD UPSIDE DOWN

I picked up a paintbrush for the first time when I was stuck in the hospital for months after a disastrous surgery. My mother brought fabric, glue, paints, and markers to my small hospital cubicle, and I made art for the first time. Suddenly, I found a way to express emotions that were too painful, complicated, and overwhelming for words. I painted my inner and outer worlds, full of joy and pain, teardrops and hearts, and lightning bolts and flowers. And I became creative with my supplies—this is how I ended up using toilet paper from the hospital bathroom, and opening my mind to exploring outside-the-box additions.

Through this burgeoning form of creativity, I rediscovered myself: the Amy who had existed before dozens of surgeries, who

had a passionate voice that no medical intervention could surgically remove. Making art inspired me with the courage to put myself out there, and emboldened me with the confidence that came from remembering that I was a person and not just a patient. My life had changed, sure, but my inner self was as vital as ever and as bright as the colors I dipped my brush into.

Each morning before the doctors came in for rounds, I'd paint feverishly whatever abstraction came to mind and whatever evolved from my situation. When I completed my pieces, I felt like I had not only gotten rid of my frustrations and worry, but had also found a place of joy and gratitude. I would put each canvas outside my hospital room, and soon the unit began to catch on, so that patients were brought by my room to see what I had created that day. Now, I was sustaining my aliveness and inspiring others, which filled me with unanticipated meaning and satisfaction.

Whatever I paint, I create from the heart. I try to focus on physical sensations, gliding my brush across the canvas, feeling the bristles press against the stretched linen, and watching each fiber imbue the scene with bright color and texture. As I guide my brush up and down my canvas, the repetitive gestures become meditative. I quiet my analytical mind and allow my canvas to become an open channel to my soul, a clear-as-day lens into what can be sensed,

but not seen. It's in this space that art happens. My painting, my soul, shines in iridescent hues, glistening with silky splotches of wet paint.

Sometimes I consider it a blessing that I have no formal art training. It doesn't bother me too much when my lines aren't perfectly crisp, or my colors aren't seamlessly blended; because I am not wedded to technical terms and steadfast rules, I am able to silence my inner critic and let passion guide me. This week is all about expressing your feelings through creating, without worrying about your inner critic, technical rules, or what might seem correct.

Reencountering the Everyday

Select an object you use every day and draw it in the space below, in your sketchbook, or on a sheet of loose-leaf paper using one continuous line and resisting the temptation to lift your pen or make corrections as you go.

Turn the picture upside down. Can you think of a new use for this upside-down object? Describe it.

Set a timer for five minutes. Return to your drawing, embellishing it as much as your imagination allows. No matter what you create, at the end of five minutes, walk away. Put your pen down.

Write about what feelings that activity brought up for you. Were you nervous? Frustrated? Excited? Determined? Creativity is about letting go of what we think is right and creating our own solutions.

Shifting Perspectives

When we reexamine our own creations through the lens of imagination, we can discover their value. In the first column on the next page, take on the voice of your inner critic and write down everything you don't like about this drawing. In the second column, take on the persona of an alien who recognizes your drawing as the most prized piece of artwork from his home planet. Write about your drawing with fresh, adoring eyes. How do your thoughts about your sketch change when you look at it through someone else's eyes?

Inner Critic Alien Admirer

_____ _____

_____ _____

_____ _____

_____ _____

_____ _____

_____ _____

_____ _____

_____ _____

_____ _____

_____ _____

_____ _____

_____ _____

WEEK 8

DRAWING AND DANCING

Creativity at its most useful (and fun) level involves not only perceiving shapes as images but focusing on the movement it takes to create them. Focusing on the sensation of creating a certain form, rather than what it should look like, is how I create most of my paintings. I love the feeling of banging a canvas against my worktable; that's how I get my backgrounds to look the way they do. The swaying tree trunks in my paintings come from embracing the feeling of fluidity in my arms and loving how they feel rotating in my shoulders. Rhythmic drawing and moving helps us focus on our body's internal rhythm. Through this simple dance-inflected style of drawing, we can really let go.

Draw from Your Body

How do you know if your art needs to go in a certain direction? Doodling is a great way to tune into your gut feelings. In the box on the next page or on a fresh sheet of paper in your sketchbook, take a pen or pencil and begin to draw. How does it feel to create this flow? How does this movement resonate in your body? Emotions may emerge but try not to analyze them too much—if you activate your analytical mind, you may cut yourself off from instinct, which is where the real creative flow comes from.

TIP: Want a great trick to tell your mind to take a back seat? Draw with both hands at once. And keep drawing circles, or a pattern you can repeat. Any kind of rhythmic repetition makes bodily sensations perceptible. After you get comfortable drawing with two hands, try leading with one body part as you draw.

Get Moving

Now, let's focus in further on feeling physical sensations as we create art. To ground us as we process each moment and to open new and unexpected doorways, we can start by walking around.

Feel your feet on the floor. Feel your toes and heels rise and then land. Do the middle of your feet touch the floor? As you walk, pay attention to the spaces in between each step as opposed to the steps themselves. Explore that space. What are the sounds you hear in between the steps? What happens in the blank space in between each step?

Now, explore the area you are in—room, studio, outdoors—with your hands. Climb the wall with your hands or run them along the ground. What is the texture you feel?

Taking the energy you felt on your walk and using the questions above to guide you, sketch in the box on the next page or on a fresh sheet of paper in your sketchbook, allowing all of the energy you felt on your walk to flow from your hands.

WEEK 9

THE SOUNDTRACK TO YOUR LIFE

I grew up thinking my life was a musical. Call it the "theater bug," or call me a "drama queen," I lived for the world of the stage. For me, singing and acting were ways I could connect with the world around me. I found comfort in the words of my favorite songwriters. I read scripts like they were novels. I would play with my *Playbills* from various shows I had seen like they were my Barbie dolls. Through theater, I had a place in this world. I could make believe by inserting myself into characters from every era, situation, and mindset, while still expressing my own individuality. When I took a deep, grounded breath from my gut and launched into a song, I could release what my heart longed to express.

Not everyone has the musical theater bug, but most everyone connects to certain songs and pieces of music, whether it is because of the story that the lyrics tell, the rhythm, or the vocals. Is there a song that you identify with?

Song: _____

Why: _____

Self-Portrait

Let's illustrate the effect this song has on you: get out your headphones or turn up your speakers. Using a pen or pencil, begin to sketch a self-portrait using a continuous line. Resist the temptation to lift your pen to stop or make corrections. Instead, let your hand continually be guided by rhythm and feeling until the song ends.

Peaks and Valleys

This time seek out a version of your favorite song that only has the accompaniment and no vocals. As you listen along, take a pen or pencil, and on a blank sheet of paper or below, draw the movement of the music. As you trace high pitches, lower tones, long notes, loud and soft dynamics, and quick tempos, again make sure to keep your pen on the paper, resisting any impulse to lift it to stop or make corrections. Your drawing might resemble a mountain range or a heartbeat.

It's All in the Lyrics

Listen to the song once more, this time placing all of your focus on the lyrics. As you listen along, take a pen or pencil, and on a blank sheet of paper or below, draw the shapes and images that the words bring to mind, using a continuous line and again resisting the temptation to lift your pen from the paper for the duration of the song.

Dance to the Music

Remember, creativity is just energy transformed. So, let's transform the energy created by the song into an interpretive dance. Don't be scared; you don't have to memorize complicated choreography or perform on stage. You don't have to be a dancer per se, you just have to move with intention. If you need help getting started, try leading with one body part at a time. First, draw circles on the ceiling with your chin. Only move your left pinky. Pretend the back of your heel is being pulled up by a string.

Whatever moves you decide to make, own them! Isolate your focus on the rhythm, the melody, and then the words of the piece, just as you did during the sketching exercise.

Challenge

At the beginning of the week put together a playlist of songs and experiment with these exercises every day.

WEEK 10

ART TOGETHER

I rediscovered creativity when I needed it most. A month after being discharged from the Columbia Presbyterian Surgical ICU, I felt isolated. I decided to join a local theater's production of *Oliver!* to once again immerse myself in the experience of being part of a community ensemble that creates theater together, a driving passion that anchored my childhood.

Being in community theater and expressing myself with others is what healed me. Healing doesn't always happen in a vacuum—it happens when we find communities where we can express ourselves, receive empathy and compassion, and build connections. The arts provide a great vehicle for this connection building. So, as much as

introspection can benefit us and we all need our quiet time, part of my healing and part of this workbook is about sharing art with others to find connection and mutual identification at a deeper level with like-minded fellow humans.

This week focus on an art you can share with others. Cook for other people, invite friends over for a game night, or host a writers' group, book club, or discussion.

Try reaching out to friends or family. Is there an old teacher you always remember? Make a list of some people who have made an impression on you in the past. Why not look them up and see if they are leading any courses, or find them on Facebook and say hello? You can always say "Hi" to a neighbor as you go out and get your mail, or seek online connections. If you can't meet in person, see if you can host an online cooking class, or join an online book club—there are also many ongoing programs at your local library or educational events or lectures at a museum or recreational center in your area.

If you prefer snail mail, try writing a postcard to someone you haven't seen in a while. Add a little doodle, and encourage them to send their own doodle back. Or you can trade lines of a story or poem back and forth—this can be done through email as well, of course.

How about dancing? See if there is a live band playing where you can move to the music. There is nothing like being able to physically move

in a space with a group of people. Doing yoga, and feeling your breath align with movement, is a great facilitator for releasing creativity.

At the end of the week, write about your experience here or in your sketchbook:

WEEK 11

COOKING

Cooking . . . when I couldn't eat? When I was first discharged from the hospital, I imagined running to my kitchen, cooking a big steak, and waking up every morning to eggs and waffles. But it would be years before I could eat or drink, years until I was surgically reconstructed. So how could I cope with my hunger? Creativity gave me safe, comforting satisfaction. Here's my inner monologue from that time:

I am home. Nope—still not allowed to eat or drink a drop! It's so hard watching everyone else eat and live normal lives that I need to isolate myself. I don't feel like my old self, or even human. It's like I'm an alien looking in on the world and hardly remembering how it felt to be part of it.

I locked myself in my room and journaled—from seven in the morning to eight thirty-five at night. I filled out hundreds of pages and slid them under the door to my mother. But *behind* my door, I knew the Food Network lineup by heart and I read my stash of cooking magazines like they were novels. I also had my secret collection of every possible drink container—flasks, baby bottles, pitchers—just pouring water from one vessel to another, imagining how it would feel going down my throat.

My obsession with food and drink and my hope for the future even inspired a new business venture. For eighty minutes a day, I came out of my room to make chocolates. I liked how the candies felt in my hands, how the sweet scent of the chocolate filled the kitchen, how smoothly it oozed into the molds. I loved to decorate each candy and sending them out made me feel just a little connected to others. Having my chocolate business made me feel engaged again. Then, once my hunger outgrew my chocolate business, I ended up baking. This happened after another surgery that didn't go quite right. But fortunately, to keep my spirits up, I found a way I could be creative and use spices as my palette. My inner monologue continued:

I'm out of the hospital now but still no eating, no drinking allowed. But this time I'm determined not to go numb again, out of touch with my emotions and memories. I have to find a way to stay connected to my emotions and I know that means staying connected to food, so, I start to cook! I make daily sumptuous feasts for my friends and family, even the dogs! And it does keep me connected. With my hands in the dough, I can actually feel. The smell of my pizza in the oven makes me cry, and the tears feel like home.

Spending my mornings cooking and my afternoons creating art, I feel filled with a sense of purpose. I'm no longer just a patient, I'm a real person! I'm inspired and feel I have the courage to put myself out into the world as the new person I've become.

Craft a Creative Recipe

Tap into your Five Superhero Senses again and think of foods that give you pleasure to smell, look at, taste, touch—even hear! (I love the crunch of a pretzel, or the snapping of a carrot stick, even the sizzle of an egg frying.)

Now, pick one of those foods. If it is a specific ingredient, find a recipe using that ingredient, or think of a general recipe category like "bread," "soup," or "chicken." The simpler the better—this will just serve as your canvas on which to create. You can start by searching for

ideas online or by flipping through magazines and cookbooks until you find a recipe that provides just enough structure and inspiration.

Next, see if there's room for inspiration. Can you use a different spice? Slice the chicken a different way? Or maybe the recipe is exactly how you'd like it. Then, act like you are in an interactive museum, and every action, every utensil and ingredient has hidden wonder—think of those nursery school kids with their spoons and basket of rice. How mindful and creative can you become? How fully present can you be in creating your recipe?

Write your recipe, listing all of the ingredients required and the steps to take in order to craft the dish.

Ingredients: _____

Instructions: _____

Bonus Activity

Draw the finished product—or a favorite moment you had while creating it.

WEEK 12

ART WITH ANYTHING

It was difficult coming out of a coma and feeling normal again. Often, I felt like a patient any time I looked at my arms, still connected to IVs, or went to another doctor's appointment. So I created a three-step action plan for myself which I could utilize whenever I felt too scared to use my voice and pursue my goals.

1. Show up.

2. Speak your truth.

3. Don't be attached to the outcome.

For me, art is healing and helps me practice these three steps. In the process of creating, I find myself and learn lessons along the way.

Making Do, Making Art

Here are some ideas for how to get creative when we feel like our resources are limited and not ideal:

- Find a piece of old wrapping paper and use it in your art.
- Find an old book or magazine and cut out words that stick with you.
- Find something with texture and turn it into a stamp.
- Finger paint in condensation on a window.
- Draw on something textured like paper towel.
- Draw the air, or draw on air.

WEEK 13

MAKE YOUR OWN
COLORING PAGES

I love this gesso coloring book craft for many reasons. The end result from this project is a great, portable drawing book that you can take outside or bring with you wherever you go. In fact, when I'm going on vacation, I will apply gesso onto a bunch of magazine advertisements and bring them with me so that when I have downtime, I can just whip out a box of colored pencils and create.

After my primed pages are set and my coloring book is ready for use, I like to draw a figure and outline it in a shimmery silver or gold paint, and then make the rest of the background dark. I find that this brings my central figure to life. I also like to make some designs on the background with Puffy paints. However you decorate your background is up to you.

Pay attention to any little nuances you can add. For example, I didn't color in my figure's earrings, and instead glued tiny beads to make jewels that literally make the image pop off the page. With simple craft glue I stuck tiny red seed beads to where the earring should be, and I added a sequin butterfly from my stash of embellishments. Before I knew it, I turned a magazine advertisement into a work of art.

Materials to Get Started

- A magazine with large images (fashion advertisements are great)
- Gesso
- A cup with some water
- A paintbrush
- Watercolor pencils and/or watercolor crayons
- Paper towels
- Optional: A few acrylic paints, Puffy paints, sequins, and decorations

To Make Coloring Pages

First, find a page in a magazine that has a large image ideal for color-ing. I tend to go for fashion advertisements with large faces or bodies.

Pour some gesso into a small bowl and mix it with a bit of water. You'll have to experiment with how much water you mix into the gesso. The more water you add to the bowl, the lighter the wash will be over the picture when you paint the gesso over the magazine page. (You want to make the page white enough that you can color onto it, but clear enough that you can still roughly see the picture you are going to color.)

With a paintbrush, apply a thin layer of the gesso and water mix-ture over the magazine page you have selected. Make sure you gesso the entire page so your paints will stick to the background. With a very light wash applied with a paintbrush, your picture should be dry within a few minutes.

Once your picture has dried, use watercolor pencils or crayons (I like the Prismacolor brand) and simply fill in the lines as you would in a coloring book. Watercolor pencils are a great tool here; simply dip the pencil into your water to create a watercoloring effect. It's fun to use the dry pencil for the outlines, and wet strokes to fill in the lines. Don't worry about how wet your magazine page becomes, just make sure you don't press your pencil down so hard that you tear the page.

Have fun, adding as many layers of color as you'd like. The more

water you dip your pencil in, the more like watercoloring it becomes. Watercolor pencils are also great for shading. Experiment with outlining your picture in a few different colors, and then blending it all in with water and your fingertips, or a scrunched up paper towel if you prefer clean hands.

If you have acrylic paints lying around, you can make art of this coloring page by creating a dynamic and bold background. If you don't have paints, you can use your pencils for the background as well, but I find that the acrylics really make your image pop.

Takeaways

As you venture forth into the next chapter, keep creativity as a mindset. Creativity gives us a safe container in which we can be present with experiences we are still coming to terms with. Creative expression engages us in a gentle dialogue with emotions that may be too overwhelming for words. You don't need to be an artist to create or to access this safe space. You just need an open heart and a mind willing to take a backseat. Here are a few more exercises to help see the world creatively:

- Take a walk and only make left turns—a lot of them!

- Imagine everything solid as liquid and everything liquid as solid. How does it feel to walk on liquid grass?

- Put a name to every sound you hear—every gust of wind or squish in the dirt.

- Pretend the world is a giant gingerbread house and view everything as something edible—are those shingles made of eggplants?

I could go on and on with ideas, but go ahead, create some of your own. Do it just for the sake of adding a spark to your day.

Share these ideas with a friend and give them a reason not to ever be bored—I'm sure they'll fire back fifteen ideas of their own.

And, if it comes naturally, see if this exchange gives you an idea that inspires you enough to create—anything. Art, music, an idea, a conversation—every moment is a chance to create something new.

Flowers I have encountered so far on this journey:

I dwell in possibility.

—EMILY DICKINSON

hope

On a journey filled with detours, hope propels us from one moment to another and urges us to keep going, no matter the obstacles in our way. But sometimes, hope is hard to find—it can live where we least expect it. So, I can't tell you where to find hope. But I can give you the tools you need to start looking for hope in new ways and new places.

WEEK 14

A HOPE-FILLED PLACE

O n our journeys, hope is fuel that gets us through the uncertain territory ahead. But sometimes hope is hard to find. When my doctors discharged me from the hospital with no idea of when or if I'd ever be able to eat or drink again, I made fake countdowns on my wall: "Seven days until I could eat again. Six . . . Five . . . Four." When I got to zero, I began my countdown again. For six years.

There's a name for this stubborn hope in fairy tales: "a willing suspension of disbelief." In *The Wizard of Oz*, Dorothy had doubts that she would one day find a way to return home, but never gave up hope that she could get back to her Auntie Em. Audiences also take part in a willing suspension of disbelief. If you read a fantasy novel, see a

superhero movie, or enjoy some absurdist comedy, you purposefully ignore the unreality of fiction or demands of logic so that you too can be taken on a journey along with the imaginary characters you're observing on the stage, page, or screen.

Step One: Visualization

Think about something you hope for—something that, as far as you know, is not guaranteed to happen. What does it look like? Is it an event? A person you want to meet? A job you hope to get? Something you want to achieve? Is it an external or internal accomplishment?

Find a place where you can be near the sunlight. If it's too cold to go outside, stand by a window. As you look out your window, gaze as far into the distance as you can and visualize what you hope for. Call this your "Hope Landscape." In this landscape, anything is possible. Take quick notes about anything you see—a tiny corner of a house in the background, a vast cloud high in the distance, the barely audible sound of a bird or car going by. Maybe it's a new friend walking toward you, or an adventure on the horizon. What does the air feel like, smell like, move like? What sounds do you notice? Now, let that list evolve into what you think you might see, hear, smell, or feel. Perhaps for a short moment a gust of wind sounds like a ladybug singing . . . or a telephone wire looks like a tightrope . . . and the clouds look like wisps of cotton candy. Your subconscious has created this landscape for you.

Now's the time to hope for what you want to happen, in your wildest and most free-flowing dreams.

Set a timer for five minutes. Write a few words about what you see (these might be full sentences or small phrases—it's up to you) outside your window. Then shift your attention toward what you are visualizing in your mind's eye, what you are hoping for. Finally, create an illustration based on what you've written. The finished illustration can be a combination of the sights you actually see and what you have hoped for and visualized—the sky is the limit!

Step Two: Countdown

Take a cue from track-and-field athletes who often envision the finish line before their big races: creating your own hope is as simple as visualizing your goal and focusing on it. Now that you have written down and illustrated what you hope for, decide how many days it will be until you reach your goal. Write that number in big bold lettering. Around that number, doodle more of the world you are hoping to see. For example, if your goal involves physical fitness, why not draw the neon yellow banner at the end of a 5k run? If you are looking for a new job—why not imagine, and doodle, your ideal office? If your goal involves moving to a new home, try sketching the front door of your dreams. Imagine what you'd want your finish line to look like—your symbol of success—and draw it in your sketchbook or in the space on the next page.

Each day this week, revisit this page and count down from the initial number by writing the descending number. As you doodle each new number, add to the drawing and watch your goals materialize before your eyes. When you reach the end of your countdown, don't worry if you haven't reached your goal—simply begin the countdown again. Your dream will take on new colors, new forms, and new meaning each time.

WEEK 15

HOPE HUNT

Can you find hope on a scavenger hunt? I consider myself a hope scavenger, creatively seeking any clues I can find in my world that might point toward a positive sign. Looking for the silver lining on any cloud might not always feel natural or easy, but when positive thinking is turned into a game, it can become an appealing adventure.

This week you are going to go on a Hope Hunt. This Hope Hunt will task you with noting certain things in your surroundings. Like all scavenger hunts, this activity asks that you engage your observational skills and pay close attention to what's around you, and includes a list of specific things to search for. Unlike most scavenger hunts, the Hope Hunt is less about *what* you're looking for, and more about *how* you're

looking for it—engaging your five senses and willing suspension of disbelief, and embracing the power of visualization.

If you remember playing a scavenger hunt game at a birthday party, or in a school activity, you'll recall that these hunts can be easily customized. For example, I remember going to a friend's pirate-themed birthday party and being sent on a scavenger hunt for chocolate gold coins. This week is less about locating concrete items and more about engaging, exploring, and empowering our hope muscles. Still, you might search for concrete items like these coins, if, for example, you've always loved the idea of a lucky penny or some other personal symbol of hope.

Getting Started on Your Hope Hunt

Consider where you live and where you spend time and pick a place to walk to—whether it's the woods behind your house or the courtyard of your apartment building. Make sure that it's a spot you interact with on an everyday basis. If you have a pencil, paper, and your creativity skills, you're all set.

Document your findings in this book or on anything that feels right to you—your sketchbook, sheets of loose-leaf paper, or a beloved journal. Just follow the checklists and prompts, get outside, and go!

TIP: Usually scavenger hunts are done in groups and can encourage teamwork and collaboration. Try doing this with friends and instead of making this a competition, make it a joint effort to find the hope around you. This can also be a good opportunity to talk about what hope means to you and to others. As a bonus, getting out there and moving your body can energize you, lift your spirits, and raise your serotonin levels.

Hope Hunt

Colors

Keeping an engaged and observant eye is critical if you want to find silver linings.

1. Find one thing in every color of the rainbow.
 Write them down.

Red: _____

Orange: _____

Yellow: _____

Green: _____

Blue: _____

Indigo: _____

Violet: _____

2. Focus on the color green. Find three different examples of it, in three different shades. List the three objects and give the shade a unique name of your choosing.

1. _____

2. _____

3. _____

Animals

Squirrels bury nuts in the ground, allowing trees to eventually sprout. Elephants use their tusks to dig for water during dry weather. And bees pollinate plants. Observing animals can build hope, as we admire how resourceful and helpful these creatures can be. Watching animals interact in nature, with each other, and with humans (maybe something as simple as a dog returning a ball to its companion) can inspire ideas for how to take hopeful and helpful actions in our own world.

1. Squirrel sighting! Spot some squirrels playing together and write an imaginary conversation for them. Three to five lines of dialogue are enough.

2. Birds—how many can you find?
 1. Your state bird (Don't know? Look it up!)
 2. Blue jay
 3. Mourning dove
 4. Cardinal
 5. Any small bird—make note of its colorings and shape and try to identify it when you get back home.

3. *So. Many. Dog walkers.* Find a dog and owner pair that look alike. Note their similar characteristics—anything from physical appearance to the way they walk.

TREES

Trees, which stand tall in the face of change and bear new life every spring, are physical manifestations of hopefulness and resilience. Trees give us oxygen, food, lumber, and shelter, and contribute to our water cycle. In their steadfast strength and ability to adapt to changing seasons, they show us that life can go on despite the worst of blizzards, rainstorms, or droughts. Notice the trees you pass by. Which one would be best for the following activities? (Note the location and shape of the tree. If you know the type, you can write that too.) Why do you think this particular tree would work for this activity?

- Holding a treehouse in its branches: _____

- Climbing: _____

- Providing shade: _____

- Giving animals a place to hide: _____

- Being used to make furniture: _____

The state tree of Connecticut, where I live, is the white oak. What is your state tree? Can you find one in your neighborhood? Look up images specific to your state or region. Find a leaf from your local tree and trace it below or in your sketchbook.

Using Your Senses

Having hope means building the confidence in yourself and the world around you that things will work out. With this belief, even if circumstances don't immediately change, we feel more at ease, more certain, even happier. How can we start building this confidence within ourselves? Let's start by going inside, with our Five Superhero Senses.

1. Close your eyes. What are three distinct sounds you hear?

1. _____

2. _____

3. _____

Now block out unnatural noise, like dogs barking, car engines, or sirens. What are three distinct sounds you hear now?

1. _____

2. _____

3. _____

2. Search for the following items and feel them for texture. Which do you like best, and why? Rate the textures in order of preference from 1 to 5 (1 being your favorite).

☐ Blade of grass

☐ Tree roots

☐ Sidewalk

☐ Mulch

☐ Brick or stone

3. Lie on your back on a fluffy patch of grass (if you don't have access to a patch of grass, this activity works just fine on a park bench, balcony, or somewhere else outdoors). What do you smell? Try to come up with three distinct smells.

1. _____

2. _____

3. _____

If you had to assign a color to each of these smells, what would they be?

1. _____

2. _____

3. _____

The Eco-Friendly Neighborhood

Noticing the problems in our neighborhoods can be frustrating, but coming up with active solutions requires that we imagine and invest in a better future—a mental exercise that engages hope.

1. What various categories of debris or trash exist on your street—paper, plastic, food? Choose one category and come up with a solution that could help eliminate this type of littering.

2. How eco-friendly is your neighborhood? What are the ways that you and your neighbors practice sustainability? Try to list at least three strategies you encounter and one piece of evidence that each strategy is being used.

1. _____

2. _____

3. _____

3. Find and make a note of three living things in your neighborhood that would benefit from humans being kinder to the earth.

1. _____

2. _____

3. _____

4. For each living thing, what is one way humans could improve its existence?

1. _____

2. _____

3. _____

By focusing on the actions being taken to improve our neighborhoods through these activities, you've seen that there are ways of enacting change and creating hope. Now that you have completed your Hope Hunt, journal about how your encounters have changed your thinking or given you hope.

WEEK 16

WHO GIVES YOU HOPE?

When I first woke up in the ICU, having a physical therapist come see me was out of the question. After all, doctors had concerned themselves for months with just the basic idea of keeping me alive. My coma lasted for months, and the biggest difficulty was keeping my swelling body down to size. But as I became more alert, I noticed a tall man with a thick Polish accent making jokes with people in the hall. He reminded me of my grandfather, who had always sung me Polish folk songs growing up. As the man moved his arms, he looked like a dancer.

Before I could talk, I was able to barely point. One never-ending ICU day, I managed to point to the man as he passed my cubicle. He

came in, introduced himself as Lev, and told me he was the physical therapist, but that he was once a ballet dancer, and he'd heard I was a dancer too.

Soon, Lev was visiting me regularly, and although I couldn't speak or get out of bed, he would help me slowly open my arms wide, like I used to do in ballet class. Soon, he was even able to help me point my toes again for the first time. I'll never forget how Lev gave me hope that I could dance again someday.

Do you have someone who has made a difference in your life? A friend who reached out at just the right time? A relative who sent a card when you needed it?

List of Legends

Make a list of role models in your life, or people who have made a positive difference. Next to their names, write down what they did that made an impact.

Imagine you are creating a map of your life: what icon, image, or symbol can stand in as a marker for each action? I'll give you my personal example: in my legend, the symbol for Lev is a ballet shoe. Now, in the third column, draw a symbol for each person who has helped give you hope.

Person	They Made a Difference By	Symbol

Reflection

Take some time to reflect on your hope heroes. Maybe you can send each person a thank-you note with a drawing of their symbol included. Maybe you can create a deck of hope affirmation cards on blank note-cards, each decorated with a symbol from your story, to keep with you just in case you come to a detour. Always be on the lookout for these symbols in your daily life; whenever I see a ballet shoe, I think of Lev and I'm filled with hope.

WEEK 17

HOPE HEROES THROUGH HISTORY

THE ONLY THING I KNOW IS THAT I PAINT BECAUSE I NEED TO, AND I PAINT WHATEVER PASSES THROUGH MY HEAD WITHOUT ANY OTHER CONSIDERATION. —FRIDA KAHLO

History is filled with role models who have managed to be brave in trying times. One of my biggest role models is Frida Kahlo, the iconic Mexican artist who began painting self-portraits after she was severely injured in a bus accident. Her quest to look inward and continually discover who she was and who she was becoming is the inspiration behind many of her surreal and fantastical portraits. She stayed true to herself, even in a body that did not move as gracefully

as her paintbrush, and although her life circumstances continued to pose obstacles, she kept her spirit alive through creativity. She's credited with one of my all-time favorite quotes: "Feet, what do I need you for when I have wings to fly?"

In your sketchbook or below, start a list of people who inspire you. They might be activists, leaders, scientists, artists, or writers. Keep an ongoing list of their names to build your arsenal of hope, jotting down a few words about why they motivate you to keep dreaming.

WEEK 18

WARRIOR WITHIN

When I woke up from my coma, hope was the last thing I wanted to think about. I had to deal with a whole new reality: the surgical ICU. While doctors worked to heal me physically, the hardest task was up to me: my emotional repair. How could I simultaneously keep up hope and battle my temptations to eat and drink—two activities that feel so essentially human and that would have killed me on the spot?

My challenge was to survive from day to day in uncertainty—sustained on intravenous nutrition, unable to eat or drink anything by mouth, until doctors could create a makeshift digestive system for me six long years later. Eventually I realized it was not the uncertainty

I feared, but the certainty that things would never get better. Was I tough enough to stand that possibility? If I wasn't, I had to become someone who was.

If I was going to survive, I was going to have to become a warrior, with hope as my bow and arrow. I needed to create a brave warrior self, a persona that would fuel me with the courage to go forth and believe things would, hopefully, improve. And if I had to go through the demanding work of healing from trauma, I wanted to make it as fun as possible—an excuse to make believe, and play—something I never felt free to do as a hospital patient.

To carry me through my journey, I knew that my warrior needed the fierceness of a tiger and the determination to flourish like a flower. *That's it! Tiger Lilly the warrior!* I ordered five hundred business cards that read, "Tiger Lilly, professional healer and warrior," just for myself. *This way*, I thought, *it's official. Tiger Lilly is here, and she means business.*

My hope revelation came when I saw myself not as poor Amy, but as Tiger Lilly the warrior. And there's a Tiger Lilly in all of us, one eager to come out and guide us through our detours.

Pick Your Fighter

This week you'll be creating your own warrior persona to give you strength when you feel like hope is inaccessible or in short supply. To get into a creative headspace, walk outside and look at the plants, animals, or natural objects around you, or alternatively, spend a few moments freewriting the names of animals and plants, objects, phrases, or any other thoughts that come to mind when you think of a warrior. You might even want to think about the role models you discovered last week. Are there certain traits that stand out?

Sketch how you envision your warrior.

Your Warrior's Story

Using the scenarios listed below, write a five-sentence story based on one of these plot twists with your warrior as the main character. By writing this story, you'll be able to discover through your own words that you can overcome any obstacle and therefore build a deeper sense of hope within. Finding hope requires creative problem-solving and the ability to look at obstacles in different ways, especially when overwhelmed by stress, exhaustion, or sorrow. Writing out these plot twists is a great way to seek positive outcome innovatively.

- Your warrior is stranded out in the wilderness in the middle of their task.

- Your warrior has just found a spot for a picnic, and a hailstorm is starting.

- Your warrior has just twenty-four hours to fix their reputation after a terrible rumor was spread.

- Your warrior is on a task force assigned to stop a band of robbers.

WEEK 19

FINDING YOUR
OWN WARRIOR TRAITS

Life is filled with many battles. They can be physical, mental, personal, social, professional, or spiritual—you name it. But if we choose to approach our battles as warriors, with grit, determination, and compassion, we can feel confident as we fight, instead of overwhelmed.

What Are Your Resilient Warrior Traits?

Focusing on my positive traits gives me courage, grounds me in the face of uncertainty, and helps me navigate the road map of my life when things take a wrong turn. For each of these traits, I have assigned myself a different symbol. Once I picked a symbol, I devoted the rest

of the day to writing poems about it, paying it homage through art and stories. The more I created these symbols and got to know them, the better I got to know myself and my inner warrior. I could envision emerging from the other side of this unknown; I had the purpose and courage to get out of my room and become a part of the world. I pretended that everything I encountered was a good luck totem, or a mystical prize left for me by a group of warriors who would help guide my way. Knowing that my path was paved with hopeful symbols helped me push past my fears and get out into the world. Here are some examples of the symbols I found that gave me hope during my recovery and their corresponding meanings:

- **Seagulls:** movement toward positive change
- **Fleece blanket:** softness and vulnerability
- **A ringing bell:** the importance of speaking up

If you recognize your resilient, warrior-worthy traits, seek out symbols to remind you of them and learn to cultivate and apply them, so you can gracefully meet any challenge that arises.

What positive qualities do you possess? Examples might include empathy, humor, optimism, persistence, or patience. There's no wrong answer!

1. _____

2. _____

3. _____

4. _____

5. _____

6. _____

Now, look around you wherever you are. What objects or symbols do you see? Find six things and write them here.

1. _____

2. _____

3. _____

4. _____

5. _____

6. _____

Choose one of those objects. Take three deep breaths and think about every aspect of that object. Is it round, hard, soft, silent, large, or hot? Imagine this object is your new warrior symbol. What does that symbol tell you about being a warrior? What trait does it embody for you? For example, if you chose to draw a doorknob, it could be showing you to be flexible and easily change directions. Write about this.

Making Sense of Metaphors and Similes

Figurative language enriches writing and speech by welcoming visual texture and evocative allusions into the mind of the reader or audience member. Maybe someone has likened you to an "early bird" or you have heard the weatherman say that it is "raining cats and dogs." These nonliteral phrases describe something as if it were something else; they link two ideas or two objects by comparison. These linguistic devices that build visual and sensory connections are known as metaphors and similes; while metaphors use direct language (for example, "the sun is a ball of wax"), similes use words like "as" and "like" to connect the ideas and objects (for example, "the sun is like a ball of wax").

This week we'll work in the realm of simile and metaphor. Each day this week, think of one trait that you believe a warrior of hope possesses. Then, pair the trait with a visual symbol that speaks to its meaning. These pairings might feel clear or universal, or they might be personal to you. It might not seem obvious right away that a night sky embodies honesty, or that a waterfall symbolizes release, but as long as it makes emotional sense to you, you are on the right track. On the next page, you'll find some examples of my entries.

April 25: Honest like the night sky.

April 26: Steady as a boat on a river.

April 27: Surrendering to change like a waterfall.

Now it's your turn. Each day this week, jot down your traits and a visual symbol that accompanies them.

1. _____

2. _____

3. _____

4. _____

5. _____

6. _____

7. _____

Now, compile each metaphor or simile that you have created this week into a seven-line poem.

How you use the figurative language in each line is up to you. Try not to plan or think too much about it. You might be surprised how meaning ignites after the seven lines are put together.

WEEK 20

BUILDING YOUR HOPE STAIRCASE

Having hope doesn't mean engaging in wishful thinking—as in "I hope I win the lottery." It's important to set clear and attainable goals. In my case, my hope was not expressed as, "Gee, I hope I can eat and drink again." What would be the point of that? I needed to break my hope down into something I could work toward. I was not a surgeon with a magic answer, but I was capable of redefining my dreams.

This week your prompt is to unpack your wishful thinking and break it into attainable goals. If you have financial stress, it's easy to dream about a sudden windfall like winning the lottery—but the chances of buying the winning ticket are slim. Instead, if you focus on making incremental changes in your life, like setting aside a small

amount of your paychecks, searching for a roommate to lower your living costs, or limiting your spending on things like dining out or beauty treatments, you are more likely to increase your savings and reduce the need to employ wishful thinking in the first place. Through planning and hard work, you can turn your wishful thinking about winning the lottery into tangible, positive change.

How can you use your hope as fuel getting you from one attainable goal to the next?

As one example, although I wished I could devour a pizza as soon as I was discharged from the hospital, I knew that in order for me to enjoy food again, I had to focus on healing. I broke down my dream for a pizza into actionable goals:

- Collecting my stacks and stacks of medical records
- Researching possible surgeons and doctors
- Making appointments with these medical professionals

This process took years, sweat, and tears, but each baby step brought me one day closer to eating again. And the closer I got, the more that hope felt like it could be a reality. And one day, it was!

Journaling About Your Hope

In your sketchbook, spend some time reflecting on your ultimate hope. What is your ultimate hope? How can you break down this dream into attainable goals? For example, if your dream is to sing on Broadway, write about the baby steps you can take to set you on a path toward performance—possibly auditioning for community theater, taking vocal lessons, or signing up for a dance class.

Hopes often come with disappointments. Maybe you tried to sign up for dance classes, but you injured your foot right before they began. Perhaps the audition didn't go as planned.

There's more than one way to reach your goal. If we lack problem-solving skills, we might give up on our goals too easily. If barriers arise, we need to be prepared. Success usually requires creative ways to overcome these obstacles, not avoiding them altogether. As you encounter these obstacles, be sure to ask yourself the following questions and record the answers:

1. What did these (if any) disappointing lessons teach me about life?

2. How can I take this knowledge and apply it to my future?

3. How can my pain be transformed into growth?

Drawing Your Staircase

Now that you've begun to look at the progress to your long-term goal as a series of steps, draw them as a staircase. On the top of the staircase, write down your ultimate hope. On each step of the staircase, write down an action that will propel you toward your goal.

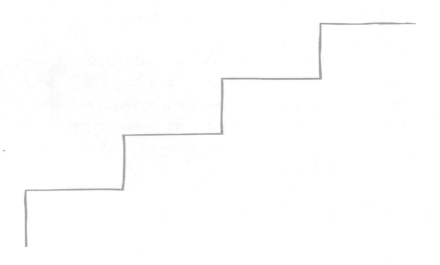

WEEK 21

PLANT A SEED

Seeds are small. They might not look like they will grow into anything, but the process of watching a plant grow can be a thrilling experience that requires patience. By planting them in dirt, we are manifesting the thought that they will grow into something expansive and beautiful. Even if you don't see anything immediately, hope requires us to act and believe that something will come of it. We have to trust that work is underway beneath the surface.

This week make a quick online search about what flowers, herbs, or vegetables can grow in your area. Do you have access to a community garden, or can you keep a pot of soil by your window? Given your circumstances, pick a seed, plant it, tend it, watch it grow, and begin

to journal about its growth in your sketchbook. You can write down simple observations about your seed, craft poems about its growth, or doodle its roots and sprouts. Draw your seedling here:

WEEK 22

SPREADING HOPE—RANDOM ACTS OF KINDNESS 101

There are many ways to plant seeds of hope besides gardening. If you perform one random act of kindness a day, it can plant a seed of hope in someone else. Performing an act of kindness can have a dramatic effect on your mood. It's calming, smile-inducing, and can alleviate all kinds of pain.

When nurses in the hospital used to walk their patients by my room to see what I had created each day, I found that having an impact on others through my improvised brushstrokes filled me with unanticipated satisfaction and meaning. Years later, I donated my painting *Dancing Girl* to Yale Hospital—it was a painting I had created as a

patient there. I couldn't think of a place I'd rather give my artwork to than the floor I had been stuck on for months and where I painted it.

After I was discharged from the hospital, I badly wanted to reconnect with the world, but I didn't know how. How could I engage with the outside world when I couldn't even drink or eat? I wrote little notes of kindness and posted them on pebbles. I even drew smiley faces with sidewalk chalk on rocks. Knowing I could make people smile made me smile too.

Step One: Random Acts of Kindness

Small acts of kindness that you do repeatedly can help you feel more connected and have a greater sense of contribution. Even watching others perform acts of kindness can have a positive effect.

This week try to find one small act you can do every day. What is a simple act of kindness you can perform where you are? Here are some examples that come to mind:

- Bake cookies and wrap them for a family in your neighborhood.
- Hold the door open for someone else.
- Make eye contact with someone and ask with intention, "How are you doing?"

- Write a list of things about a friend that make you smile, and leave the list for them where or when they least expect it.

- Share something positive online, or email a positive article to someone you know.

- Go outside and use natural materials—like twigs, leaves, and pebbles—to make art from found objects.

- Wander around your neighborhood, observe interactions, and ask yourself, "What's a compliment I'd personally love to receive?" Write it on a sticky note and stick it under a park bench.

- Using chalk, draw a hopeful message on the sidewalk.

> **TIP:** You can make your own sidewalk paint by combining one-part water with one-part cornstarch, and liquid watercolor or food dye.

Step Two:
Creating Hope in Your Community

Embracing my warrior within gave me the bravery to come back into my community. When I could give others around me hope, it filled me with hope too. So, summon your warrior self and embark on a creative kindness outing. With your sketchbook in hand, get out into your neighborhood, town, city, or online, and ask people to define hope in their own words. I've provided some leading questions below to guide your conversations and get you started.

- What is a community?

- Do you think your community emits hope? If so, what are some examples of hope in your community?

- What are ways of expressing hope toward a community or individual?

- What are the benefits of having hope?

- Are there any risks with having hope?

- Does hope happen naturally?

Step Three: Reflection

At the end of this week, sit down, set a timer for five minutes, and journal about how performing these random acts of kindness and engaging with your community made you feel.

WEEK 23

MAKE A HOPE PLAYLIST

Can you name a song that has the word "hope" in it? Free associate the word "hope" with five additional words. For the word "hope" and for each of the five associated words, select a song that contains that word in its lyrics, and create a playlist of these songs. Record your playlist on the next page.

1. _____

2. _____

3. _____

4. _____

5. _____

6. _____

Listen to your playlist while you draw. Listen to it while you cook. Listen to it while you catch up on emails. Listen to it while you deal with unpleasant activities: paying bills, doing the dishes, sitting in traffic, or reading the news. How does listening to positive, hopeful music impact your experience of these sometimes tense or unappealing activities?

Challenge

Do something with your playlist to bring it to the outside world. Hope spreads and germinates. Once you plant your seed of hope in the universe, it grows and grows. Share the playlist with someone whom you think needs it—hope is infectious, and they might be able to deliver some more hope back to you. Dance to your playlist in public. Sing out loud to your favorite song. Play it outside. Post the lyrics on your mailbox. Get creative!

WEEK 24

CHARTING YOUR HOPE

This week let's create your hope map. Hope is more than just a state of mind. It's an action-oriented strength. It gives us direction. So turn on your hope playlist and start meditating on your ultimate goal.

Take a blank piece of paper or one with preexisting text like a newspaper page or an old road atlas. (The print and images can add extra texture to your hope landscape.) Across the paper, trace a line from where you are now to wherever on the map you imagine your achieved hope to be. Now, you'll chart the path to get there.

Remember that legend you made with symbols for each role model in your life? Draw these symbols on your map. These symbols will help guide your journey and help you remember the people in

your life who have given you hope, and the lessons that they have taught you.

Remember those clear attainable goals? Pick three or four of them and plot them across a map of your design, writing them down in clear text.

As you create your map, ask yourself what small actions you can take that will start moving you closer toward your ultimate hope? This is the fuel that will transport you to your destination. Hope helps us keep traveling forward while holding a difficult present and uncertain future.

WEEK 25

CREATING YOUR HOPE
VISION STATEMENT

When I thought about my life taking paths I didn't expect, I visualized a detour. Detours force us to explore new opportunities. When we can't go in the direction we anticipated, we've got to switch gears and adapt. We have to resource inner strengths that we never knew we were capable of accessing. When we achieve the unthinkable, we discover who we really are.

I hope to inspire people to flourish because of, rather than in spite of, challenges.

That's what drove me to create my own hope vision statement:

#LoveMyDetour aims to encourage growth and healing by sharing our stories; to transform communities by inspiring people to open their minds and reframe their view of "detours" into a new direction for life.

I wanted to spread this hope around the world. By writing out my statement, I could envision this hope for myself.

What is your hope vision statement? Start writing some thoughts below or in your sketchbook. If no words come, start with the first thought that comes to mind. If you have trouble getting your ideas onto the page, switch gears and doodle your words. Once you finish the first word, let the next word come naturally to you. Don't let your pen leave the paper. If you can't think of another word, keep using your repetitive doodling tools to build up each letter. Eventually another letter, word, or idea will come.

Takeaways

As you complete this hope section, take some time to reflect on your daily activities. What are some practices of hope that you can incorporate into your routine? Think about what fills you with hope—the way that light hits a blade of grass, the scent of a fragrant spice. Maybe you find hope in other people, or within your warrior self. How can we plan our days so that we find more opportunities to encounter hope? Hope is just as essential to our health and happiness as working out or brushing our teeth is, so make time to seek it out each day by journaling, performing acts of kindness, listening to music, and engaging with your community. Don't wait for hope to dawn on you like a beam of light; harness your inner warrior and create your own hope—this momentum will propel you from one part of your journey to the next.

Flowers I have encountered so far on this journey:

After nourishment, shelter, and companionship, stories are the thing we need most in the world.

—PHILIP PULLMAN

storytelling

don't have a story you hear every day. For a long time, it was a story I couldn't understand, like the sick plot of a psychological thriller. My life was out of control. I called a therapist. She listened to my flustered ramblings, then calmly told me that I had to tell my story.

Tell my story?

"Yes," she replied. "You have to say in words what happened to you."

I hung up and never talked to her again. She was oversimplifying things. I had thought a lot about my story; I didn't know why I had to verbalize it. What could words do? I spent a few months pretending everything was okay, but it wasn't. Then I thought, *What the heck, I'll say it.*

I tried, but I couldn't speak. At that moment, I knew the therapist was right. Until I could use the power of words to express what happened to me, I would not heal. It took years before I could articulate the turmoil rattling around inside of me. The confusion, the pain, the anger—the losses. I had all kinds of journals ready to go, the Hallmark kind with the pretty covers and the inspirational quotes,

believing there would come a time when words would flow through me and guide me back to myself.

And one day, I took one of those journals, opened it, and began to write.

The Power of Stories

Storytelling, since the beginning of time, has driven change, created movements, and empowered those who never knew they had a story to tell. Stories transform our personal experiences, enrich our communities, and teach others the lessons we have learned for ourselves—they are reliable patterns we can lean on in a world with no map.

This section is not just about learning to tell your story, speak about it, write your memoir, or write any kind of book at all. In the weeks ahead, you'll discover how everything around us has a story to tell. Once we uncover the untold stories and hidden lives that surround us, we can never feel alone, uncertain, bored, or uninspired. Everyone has a story—and when we learn them, we see strands of inspiration and connectivity uniting us all.

Through telling stories, we feel connection and empathy. We realize we're not alone. No one else can write the story of our lives; our stories are part of what makes us unique. Yet in telling our stories we find commonality: we all can relate to certain themes and feelings.

Telling our stories helps us process what happens in our lives. It's not the details that matter—suffering is relative. By sharing our stories, we can connect with others who feel the same way. We suddenly feel less alone in our ever-unfolding narrative. Through our shared experience, we can heal.

And I had a lot of healing to do, which is why the words seemed to flow through me and never end. By the end of every night, I was exhausted, as though I had just spilled my entire soul into my laptop. But I was relieved—one more day that was documented.

The writing itself was not the accomplishment. The writing was how I let myself believe that I was my own hero and every day was a new chapter. I had a story to tell, a message to share.

But the big accomplishment was finally being able to share my words. My one-woman musical autobiography first appeared as stapled pages of my journal, printed from my laptop—just a few pages from the thousands of journal entries I had completed when unable to eat or drink for years. I selected sixteen songs—some of which I had written—that had always resonated with my journey and me, and loosely strung them together to sing for my own therapy. I'd perform

them for my parents, or my dogs, but mostly for myself. Through the songs, I could allow myself a safe place to feel the charged emotions I was still trying to process from years of medical trauma.

I called it my "world in a binder." My parents called it "Amy's little play." It was no surprise when I received many looks of concern and gentle warnings when I decided to book a theater in New York for my world premiere.

I performed my show, *Gutless & Grateful*, for the first time in New York City in October 2012. It was a frightening, bold, vulnerable, and breathtaking experience. In it, I told everything—the painful parts, the medical journey, the joyful, and the infuriating—with music and drama, and most importantly, humor. I had played roles before, but for the first time, I was honestly revealing my own medical and emotional struggles for hundreds of strangers every night. It was a risk to lay my soul bare, but the reward was in how my own vulnerability caused others to become vulnerable and moved by my struggles. After each of my shows, many people approached me and wanted to share their own stories. I started to put a guest book in the lobby and people would write novels for me. People also found me on Facebook and wrote about their own difficulties and how I had inspired them to think differently with my message of hope, gratitude, and resilience. I hope these exercises will inspire you to tell your own stories.

WEEK 26

STORIES, NOT JUST FOR KIDS

Everyone loves a good story. But when I was anxious about my uncertain future out of the hospital, I didn't know what kind of story lay ahead of me. Then I thought about some of my favorite Disney movies. I'm not a lion, or a king. I don't live under the sea, can't transport myself in a magic pumpkin, and don't have 101 dalmatians. But, like the Beast, I've felt betrayal. Like Ariel, I've looked for hope in the oddest of places. Like every villain, I've been so angry I haven't known what to do with myself. I've also felt *Lady and the Tramp*-style love when I thought I couldn't feel at all.

Is there a book or poem you've read that has always stuck with you? A certain metaphor from a whimsical children's story that

resonated with you as a child? I remember always loving the book *Harold and the Purple Crayon*, in which the main character, Harold, can access faraway lands through the power of his art. If a fictional child could summon his own worlds, I could too.

Think about the stories that stuck with you from your childhood: storybooks, children's shows, fables, nursery rhymes (stories come in all shapes and sizes).

List three of your favorites below.

1. _____

2. _____

3. _____

Now, selecting one, set a timer for one minute. In the space below or in your sketchbook, quickly doodle a character, image, or symbol you remember from that story.

After the minute is up, freewrite around your drawing what else you remember about that story. Why do you think you still remember that? Has an image from the story or a part of the story inspired you today? Was there a certain moment in the recent past that sparked your memory of the story?

WEEK 27

MYTHOLOGY

Do you remember the first myth or fable you learned? Was it the story of Pandora's box? The Garden of Eden? *Star Wars*? My journey with myth started with a ten dollar oversized mythology bargain book I bought because I liked the pictures. In all of the archetypal stories—folktales, fables, mythology, children's books—obstacles present adventure and overcoming challenges becomes the essential plot. Every obstacle or suspenseful twist is different and memorably unique. A Greek god might have gotten trapped in the sun, or a chicken thought the sky was falling. Whatever the conflict the stories were dealing with—hurt, fear, pain, uncertainty—I could find something

to relate to. And best of all, reading stories gave me something else to think about besides my own internal musings.

In one big bargain book I encountered characters who struggled with gods and demons, whales and spiders. But I also found that every victim who was preyed upon ended up with some kind of treasure, lesson, or positive outcome gained by going forward. The characters, places, and specific events were different, but the journeys took on the same pattern, a pattern I was traveling too. In many of the stories, the protagonists were embarking on actual trips—journeys that required persistence, faith, and resilience. Sometimes on their journeys they were wounded, but by the story's end, they were healed. Looking down at my body, I knew I had major healing to do. But how would my final transformation take shape? Reading story after story, I got a feel for how a dark, unexpected journey could go.

In Joseph Campbell's *The Hero with a Thousand Faces* I learned about the hero's journey—a pattern that has pervaded books, films, and stories since the beginning of time:

> The story of the hero's quest typically begins in the hero's ordinary world, when he or she receives a call to adventure from a herald. Many heroes initially refuse the call, until a mentor reassures them that they are capable. After this meeting with the mentor, they must enter the world of the quest. They meet allies

and enemies along the way and are tested frequently. As they near the source of their quest, they usually face one final ordeal. Upon their success, they take the object of their quest, and make their way home. The way home is not always easy, but eventually they return to their ordinary world with their prize.[2]

By learning about heroic struggles, failures, and triumphs, I began to form a road map for my own hero's journey that seemed to connect me to all of humanity, even as I peered out through my bedroom window.

2 Joseph Campbell, *The Hero with a Thousand Faces* (New York: Pantheon, 1949).

Stages of the Hero's Journey

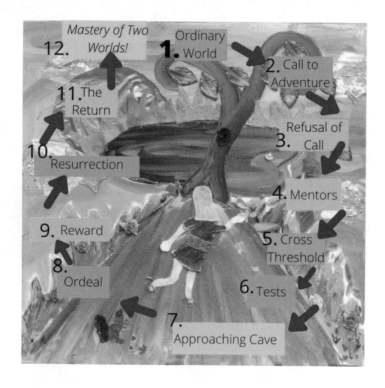

12. *Mastery of Two Worlds!*
1. Ordinary World
2. Call to Adventure
11. The Return
3. Refusal of Call
10. Resurreciton
4. Mentors
9. Reward
5. Cross Threshold
8. Ordeal
6. Tests
7. Approaching Cave

1. **Ordinary world**: The hero starts in the ordinary world, as an ordinary person. (My ordinary world was a comfortable house, filled with family and friends and my dreams of Broadway.)

2. **Call to adventure**: A challenge turns the hero's world upside down. Suddenly, she (or he) is snatched from everyday life and called to another realm.

3. **Refusal of call**: This new world is scary, and the hero might refuse its call . . . but then there would be no story to tell.

4. **Mentors**: Sometimes it takes a special mentor to give us the courage for the long road ahead. The hero meets with a mentor.

5. **Cross threshold**: The hero begins her quest (physical, spiritual, or emotional) by committing to tackle uncharted journey.

6. **Tests**: Obstacles are on the path. The hero must overcome challenges on the journey.

7. **Approaching cave:** This can represent many things in the hero's story, such as a terrible danger or an inner conflict that the hero must face. It represents the doubts and fears the hero must confront in order to gain the courage to continue.

8. **Ordeal:** The final battle. This requires the hero draw upon all experiences gathered on her path to the cave, in order to overcome her most difficult challenge.

9. **Reward:** After defeating the enemy, the hero becomes a stronger person.

10. **Resurrection:** The hero has to return home with the reward, whatever that may be. By this time, the hero knows that danger could be lurking and has to commit to the last stage of the journey—a difficult decision.

11. **The return:** This is the climax where the hero must have the final and most dangerous encounter. Everything is at stake!

12. **Mastery of two worlds:** This is the final stage of the hero's journey: where she returns to the ordinary world as a changed person. The hero incorporates what she has learned from both worlds after growing and learning, and shares this with her community.

Mastery of Two Worlds

At the end of the hero's journey, the hero goes home. However, they cannot fully return to the ordinary world they lived in before the call. Because they carry the lessons of adventure and battle with them, they are indelibly changed and in turn change the world they return to. As a master of both realms, they can pass freely between the special world and the ordinary world, and share their wisdom and insights with others, blurring the lines between darkness and light.

Why should we embark on the journey if it introduces darkness into our ordinary world? Why introduce a fear like Dorothy's in *The Wizard of Oz*, that we might never get back to the home we long for? Why not save the adventure stories for books? Well, we don't really get a choice. We all encounter some kind of challenge in our lives. Darkness is inevitable. That special world is always lurking. By getting familiar with the hero's journey, we can find strength and comfort in its structure and embrace our challenges as exciting rather than insurmountable. And when we become the master of the two worlds, the special and the ordinary, we reach the final step: freedom to live.

Drawing the Journey

As heroes, *we* create our own transformation, like snakes shedding skin. Our hero's journeys change us—heal us—and allow us to tell the stories that change the world.

Pick three of those points in the hero's journey and dedicate a page in your sketchbook to each of them, reflecting on your own experiences with home, obstacles, and perseverance.

Using one of the following methods for each page, illustrate the steps in your hero's journey:

1. Call and response. Stand over your sketchbook. Draw one shape, stroke, or mark, and let that mark be your "call." Respond with your body by enacting a movement. If what you draw is a road sign, what action does it indicate that you take? As you continue to make marks and subsequent movements, notice how your creation becomes a kind of dance for you. Listen to the marks you make and feel in your body where they tell you to go.

2. For another page, draw your design using your sense of touch as your guide. Placing your hands on the page, begin to feel your fingertips shaping the scene you're imagining. (Think of it as finger painting with invisible ink.) Now step away and look at the blank page. What do you see taking shape there? See if you can sketch this using as few marks on your page as possible. Let your message speak in the empty space.

3. For your third page, go into your Detourist Collections shoebox and select clippings. Create an image on the blank page by pasting the clippings and art onto the page with glue.

WEEK 28

RECOGNIZING TROPES

Every form of narrative has its own path, and the hero's journey is just one example. As we progress through these weeks, remember that it's not so much the structure of your story that matters, but the content. Story structures are just templates to help you organize the events of your life so that you can reflect on them more easily and collect your thoughts.

In literature, certain story lines and structures arise time and again and begin to feel repetitive; but in life, it can be comforting to recognize the patterns in our own stories. Getting familiar with commonly used story lines gives us the power to view an event in our life any way we choose. The story tropes, or recurring literary plot devices, that I'm

going to introduce you to will help you look at any story—including your own—through fresh eyes.

What Is a Trope?

In literature, a trope is a story line, character, or device that's used over and over again. Tropes are cliché—but at least they are predictable. Here are some frequently used story tropes:

1. **Journey and return:** The protagonist embarks on a heroic journey and then tries to get home.

2. **Love triangle:** Two distinctly different characters fall for the same person, or one person falls in love with two people. This trope is frequently found in romantic comedies and dramas.

3. **Conspiracy:** A secretive group hatches an evil plan that the protagonist must uncover and overcome.

4. **Overcoming the monster:** Anyone who watches superhero movies or knows the Rocky films is familiar with this plotline, in which an underdog overcomes some kind of monster. Every story needs a monster. If you focus only on positive aspects of your story and don't discuss your monsters (whether they are villains you encounter or darkness within), you aren't giving the whole story.

5. **Rags to riches:** A story in which a character rises from poverty to wealth.

6. **Rebirth:** The main character has an internal revelation or a catharsis. In some cases, this trope is shown by an actual death and rebirth, like the story of the phoenix: a mythical bird that resurrects itself from its own ashes after death.

Finding Tropes in the Stories Around You

In a magazine or online find a story that interests you. Read it and reread it. Can you locate any of the tropes from above in the story? Check the boxes next to the trope if you recognize it in the story.

☐ Journey and return

☐ Love triangle

☐ Conspiracy

☐ Overcoming the monster

☐ Rags to riches

☐ Rebirth

Illustrating Tropes

Take the trope that you recognized in the story above and illustrate it in the space below. Here are some ideas to get you started if you are stuck. If you located a love triangle, pick three competing colors and let your passions run wild. Rebirth? Why not doodle an intricate circle? If you focused on conspiracy, play with shading or introduce mysterious elements into the corners of the frame.

WEEK 29

PLAYING WITH GENRE

Defining Genre in Our Own Lives

Genre is defined as a category of artistic, musical, or literary composition characterized by a particular style, form, or content. Literature has four main genres—fiction, nonfiction, poetry, and drama—but within those broad categories lie dozens of subgenres. In fiction, for example, genres span from science fiction to comedy, romance, spy thriller and beyond, and serve to orient readers in terms of which tones, tropes, and topics to expect. When we select stories by genre, we revel in the certain comfort that we know, on some level, what might happen. It can be tempting to fit our own experiences into the tidy structures that genre presents. It can be appealing to categorize

certain memories as sad, tragic, or disappointing—but when we do that, we ignore the silver linings, the little lessons, and the flowers we encountered among the weeds.

When we write our stories in different genres, we can change how we perceive events in our lives. We might view an experience as a stumbling block, something that held us back. We can get stuck in this thinking; it may not be easy to reframe how we view obstacles or detours. After all, it is not easy to stay positive or put on a happy face when experiencing difficult events. However, if you examine your story through a new lens, you might understand it differently.

I'll go first. One of my most painful memories is when my doctors told me that I may never be able to drink fluid again—and I didn't for two years—until my parents took me to see Dr. Stanley Dudrick. I've written the same story in different genres in order to gain insight into the emotional experience.

Western

My household was suffering—barren, parched. Dudrick rode into town one day, tipped his hat, and gave me a vial of cold water. "Try it," he muttered. "See what happens." He rode off into the sunset before I could thank him as the cool, refreshing slurp moistened my aching throat.

Science Fiction

After the *Andromeda* crashed, marooning us on the dry planet, we had been desperate for food and water. Unbeholden to the sun and moon of Earth, time seemed to move at a slug's pace. A day became two years. Only thanks to Dr. Stanley Dudrick did we survive. He managed to secure his medical kit from the rocket ship's rubble. Inside? Nutrient pills and three glorious canisters of water. I was parched, but skeptical. What if the chemicals from the crash tainted the water? Was it safe? "Try it," he said, "see what happens."

Step One: Reflect

Here's an exercise that shows how creatively exciting it can be to reframe your narrative. In the space of a paragraph or two, write about something in your past that has troubled you. It might be something that happened years ago, a frustration that continually pops up, or something that is challenging you today.

Step Two: Reframe

This time put a new spin on your story by writing it in a different genre. Either by introducing fictional elements into your personal story or folding in details that you had previously left out, turn your car crash into a science fiction odyssey, turn your bad date into slapstick comedy. After you complete this exercise pay attention to how you are feeling about the memory. Do you notice any new details emerging?

WEEK 30

BUILDING YOUR STORY INVENTORY

During the months when I was coming out of my coma, my mother would read me any inspirational autobiography she could find. I couldn't stand them. After all, why would I care about these great comeback stories when I couldn't even breathe on my own? Their triumphs felt like a slap in the face. However, as I started getting better, I began to relate to the protagonists in different ways. I could visualize myself in their shoes. *Maybe that could be me.* Suddenly, those books empowered me by giving me hope with their feasible goals and realistic role models.

Keeping a List

This week you will begin to keep an inventory of all the stories that you encounter: things like Greek myths, biographies, and short stories.

To organize your list, pick a clean page in your sketchbook and draw a line down the center to create two columns. In one column, write down the title of the story that you've read alongside the date that you read it. In the column beside it, write down one idea, thought, character, or image from that story that resonates with you.

Creative Ways to Build Your Story Inventory

Your materials? Tennis legend Arthur Ashe once said, "Start where you are. Use what you have. Do what you can." You don't have to limit yourself to words. Here are some fun ways to enliven your list:

- Pay homage to the main character of the story by drawing their portrait.

- Cut out individual words from magazines to spell the titles of the stories and books you read.

- Record each title in a code that only you are privy to.

Story Search and Journaling Activities

If you find yourself staring at a blank page without knowing where to begin or losing your motivation to read a few weeks in, it might help to seek out specific kinds of stories. Here are two prompts that will help orient you toward new stories along with journaling exercises to help you process what you have read.

1. Find a story that deals with the element of fear.
 Journal prompts: In the story you've read, what do you think about how this person related to their fear? What was their journey? What is your biggest fear? Do you think it's holding you back from accomplishing all you could in your life? Do you feel you are ready to begin to overcome it? How will you begin?

2. Find a story about a relationship between two people.
 Journal prompts: How do they communicate? Are there barriers or obstacles they have to overcome in order to better understand each other? Spend five minutes journaling about five important people in your life. Write down one example of a recent communication with each person. For example, journal about the last time you

had dinner with a friend. Once you have written out the entire memory, look back at it and ask yourself how you feel about the conversation. Was there something that you wish you had said or said differently? Something expressed without words, through eyes, body language, or actions? If you could change anything about the communication, what would it be?

WEEK 31

STORY THROUGH STRUCTURE

In storytelling, there are many different ways to order events and provide structure. By experimenting with different structural forms in storytelling, we can become more comfortable understanding our own paths and determining where we would like to go next. When we take ownership of how we tell our stories and become comfortable sequencing our lives in different ways, there's no telling where we might be able to go. This week we'll experiment with two structures: the three-step structure, commonly found in fairy tales and romantic comedies, and the six-step structure that is commonly found in Pixar films.

Three-Step Structure

Fairy tales take on a three-step structure, beginning with "Once upon a time . . ." and ending with "And they lived happily ever after." Romantic comedies also carry a three-part foundational structure: Boy meets girl, boy loses girl, boy and girl get back together. (Or girl meets boy, girl meets girl, or boy meets boy.)

Because writing our stories can be daunting, it can be helpful to organize them into a simple three-part structure, taking a few moments to write about each step of the story before putting them together.

To build your own three-part story arc, consider a challenging moment in your life and answer the following questions in the space provided or in your sketchbook.

1. **Beginning:** What is the context or background of your story? Where were you when the challenge occurred? How old were you? Who were you with?

2. Problem: What issue arose that you had to deal with? Why was it a problem? Who was affected?

3. Resolution: How did you resolve the problem? What personal strengths did you call on to overcome the problem? Who supported you?

Pixar Story Structure

The animated film studio Pixar uses a fairly simple six-step model to create universal stories with a clear purpose. *Finding Nemo* is a clear example of a story based on this structure. Once upon a time, there was a widowed fish named Marlin who was protective of his only son, Nemo. Every day, Marlin warns Nemo of the ocean's dangers and tells him not to swim far away. One day in an act of defiance, Nemo ignores his father's warnings and swims into the open water. Because of that, a diver captures him and he ends up as a pet in the fish tank of a dentist in Sydney. And because of that, Marlin sets off on a journey to recover Nemo, enlisting the help of other sea creatures along the way, until he finally finds Nemo and learns that love depends on trust.

The basic structure, which you can find outside of Pixar in stories like *The Wizard of Oz*, goes like this: Once upon a time there was [blank]. Every day, [blank]. One day, [blank]. Because of that, [blank]. And because of that, [blank]. Until finally, [blank].

To build your own six-part story arc, consider a challenging moment in your life and answer the following questions in the space provided or in your sketchbook.

1. Once upon a time there was a: _____

2. Every day: _____

3. One day: _____

4. Because of that: _____

5. And because of that: _____

6. Until finally: _____

Writing Your Story

Now that you've plotted your story through two different story structures, pick one and write your story in the space below or in your sketchbook.

WEEK 32

STORYLIBS

This week is all about impulse, speed, and embracing randomness. The less thinking, the better! In spontaneity we can often discover things about our paths we never would have noticed otherwise.

Variation One

You're about to cook up a story, but first you have to make your list of ingredients. The key here is to find freedom within the limitations. Or in other words, don't think, just write. Lack of time can be a great friend. In your sketchbook or on a sheet of paper draw four columns, labelling them A, B, C, and D, and set a timer for five minutes.

Column A: Write six words that describe your identity. (It could be sister, artist, teacher, friend, female—whatever words come up for you first.)

Column B: Write six objects you might come across in your daily life that are of importance to you. Don't think too much about it, just list the first six objects you think of. (Some ideas might be toothbrush, doorknob, cell phone.)

Column C: Write six different longings, needs, or desires you have. (Examples are love, acceptance, peace, understanding, strength.)

Column D: Write six obstacles or hurdles you've faced in the past. These can be as specific or general as you wish, but the rule is that they have to be phrased as one word. Losing a job could be "fired." Other words might be impatience, temptations, or deadline.

Find a single die from a board game or somewhere else. (If you don't have one then write the digits 1 to 6 on little scraps of paper and pick randomly.)

Roll your die four times so you have four numbers, or pick four scraps of paper at random.

As soon as you have your four random numbers, take the corresponding item that you've written down in each of the four columns to create a short story outline using this template: Your character (column A) longs for (column C) but faces an obstacle (column D) and only has one prop (column B) to save the day. What happens?

Set a timer for five minutes. In the time you have, write your story using your "ingredients." Hint: Tell your inner critic to take a vacation. The wackier, the better.

Variation Two

In your sketchbook or on a sheet of paper, draw four columns. With material that you have on hand—such as paper, magazines, leaves, newspaper, or napkins—cut out five silhouettes. Imagine that these are five different interpretations of your strongest self. Give them names and write the names in the first column.

In the second column, write five different kinds of storms or natural occurrences. What come without warning? This could be an earthquake, rainstorm, blizzard, gust of wind wiping a trail away, or something else.

In the third column, write a list of five things that speak to you. What appeals to you? Candles? Netflix? The human heart?

In the fourth column, write your Five Superhero Senses (you know them well by now).

Find a die from a board game or somewhere else. (If you don't have one, then write the digits 1 to 5 on little scraps of paper and pick randomly.)

Roll your die four times so you have four numbers, or pick four scraps of paper at random.

As soon as you have your four random numbers, take the corresponding item that you've written down in each of the four columns to create a short story outline using this template: Your character (column 1) is traveling, but all of a sudden, a natural disaster (column 2) sweeps in. Luckily, your character has their lucky charm (column 3) and a superpower sense (column 4). What happens next? Set a timer for five minutes and write, letting your imagination run wild.

WEEK 33

CINEMA OF THE REAL

Merriam-Webster defines imagination as "the ability to form a picture in your mind of something that you have not seen or experienced" and "the ability to think of new things." Children have vivid imaginations, and using their imagination is part of their everyday. As a result, creative visualization—using one's imagination as a door to possibilities and thinking outside the box—comes naturally to them and they regularly see creative opportunities. For children, any event in their lives could be an exciting premise for a film.

Most children, however, aren't aware of the log line—a brief, one-sentence summary that states the central conflict and emotional context of the plot—in which the premises for films are typically

presented in showbiz. Like an elevator pitch, log lines are brief (just under one hundred words) and meant to capture interest right away. For our purposes, crafting log lines will help restore our connection with our imaginations and creative visualization—things that people often lose as they grow up and are sucked into a world of ready-made images. By writing a log line, we can finesse the power of creative visualization within the productive confines of constraint.

This exercise also helps us find the movie magic in our own experiences. If you could tell your life story in less than one hundred words, what would you write?

Drafting Your Log Line

A film log line must always include the protagonist, their goal, and the antagonist or antagonistic force. For example, many log lines take on this basic structure: When [INCITING INCIDENT OCCURS], a [PROTAGONIST] must [OBJECTIVE], or else [STAKES].

Here are some bullets to further outline the elements at play:

- **The protagonist:** Don't use names, just a description of their occupation, livelihood, or condition. For example "An alcoholic surgeon . . . "

- **Inciting incident:** The inciting incident propels the protagonist into action. For example, "An alcoholic surgeon is accused of malpractice by a patient . . ."

- **The objective or goal of the protagonist:** This is usually in line with your second act turning point and can be as abstract as "love," or as specific as "to take my neighbor to the movies." If we continue with our log line, the objective might be work related. For example, "An alcoholic surgeon is accused of malpractice by a patient and must fight to keep his job . . ."

- **Stakes:** The stakes refer to what is at risk of being gained or lost in the story. In our case, the surgeon must keep his job, or else his wife will leave him. Now that the stakes are established, we have our entire log line: "An alcoholic surgeon is accused of malpractice by a patient and must fight to keep his job or else he won't be able to keep what is most important to him: his wife."

Fill in the different elements of your log line (in fewer than one hundred words) in the space on the next page or in your sketchbook, and then draft the log line in a single sentence.

Protagonist: _____

Inciting incident: _____

Objective: _____

Stakes: _____

Log line: _____

What would you call your movie? It can be daunting to label your entire life story with a title. Play around with images, metaphors, names, and places until something feels right. To give yourself some boundaries to work with, limit your title to six words or fewer.

Title: _____

Poster

Next, create a poster for your movie. Begin by doing a quick online search for the posters of your favorite movies. Which posters have stuck with you through the years? Which ones captured your eye and made you want to know more?

A great movie poster captures the feeling of the movie and hints at the plot without giving the story away.

Think about your title and the themes of your life (romance, adventure, comedy), and use the colors, shapes, and lines that feel resonant. Consider the lettering you choose; are you looking for a childlike scrawl, sophisticated calligraphy, a dark and mysterious font? Using all capital letters will convey a sense of authority and strength, while small, barely-there text will impart subtlety and beg for close attention.

Create your poster in the space on the next page, in your sketchbook, or on your computer. Remember to put your name on it in big print. When you are feeling less than, take a look at your poster and remember that you are the star of your own story.

WEEK 34

PULLING INSPIRATION
FROM THE EVERYDAY

While last week's exercises centered around applying a cinematic lens to our lives in order to view our own stories differently, this week's focus is on the forms of storytelling that incorporate everyday occurrences—just as they are—into their structure. Documentary theater, for example, captures human stories. It shows that you don't need to be a fantastical character to make an exciting story.

This week pay attention to the stories around you, ones that you might have overlooked in the past. With a pen and paper handy, take on the role of documentarian: capturing the sights, sounds, and songs that play around you and making note of the ordinary. The more details you write down, the more stories will emerge.

At the end of the week, go through your inventory of notes and create something from what you've written down: a dialogue, a comic strip, a poem, or a short story.

How to Look and What to Look For

1. **Careful observation**. The reality of things is often different from what we assume. Look at a human face, or the lines on tree bark, what do you notice up close that you might overlook when passing by?

2. **The right details**. My living room contains a sofa, a lamp, a desk, and a desk chair. That doesn't give you much of a mental picture. That might be any living room. But if I describe what's unique—the smell of breakfast cooking, the texture of the marble counter, the height of my chair, the wear marks on the carpet, you can get more of an image. When I add the picture frame with no glass cover because it broke when my IV pole fell on it, then you get more details of my life. It leads me into thinking about how I felt when "chained" to an IV pole in the "comfort" of a normal home.

Capturing the Surrounds

1. **People-watch.** The people around you can become fictional characters or the subjects of poems. You can give them roles in your writing, or just borrow details from them: your neighbor's nervous laugh, the shiny makeup your mother's friend wears that makes her look like she's made out of plastic. Make notes about people you know; take your sketchbook to a coffeehouse or a hotel lobby and describe them: their appearance, their body language, their voices, the way they relate to each other. You can go beyond documenting and write what you imagine as well. What do you think that woman's name might be? Where do you think she lives? What is she thinking right now? What is she hiding in that big purse? Any of these answers can be the beginning of a story or poem.

2. **Listen.** Eavesdrop in restaurants and stores. Listen to your own family and friends, and really listen. Not just to what they're saying, but to the words they use, the pauses they take, the unique rhythms of their speech. And write down pieces of speech when they are still fresh in your ears. If you wait too long, you'll find the sentences coming out in your own voice. Learning to capture different voices on paper will help you with dialogue for stories or scripts. It can also be a source for poetry.

3. **Take a walk.** Describe your neighborhood. Describe the weather, the colors and textures, the light and shadow. Go beyond what you see—describe the sounds, the smells, the feeling of the air on your skin. Look for the surprising details, the ones that aren't quite as you'd imagined, the ones you could never have made up.

4. **Take a field trip.** Are you writing a scene in a police station? A city dump? Visit one. Write down the details that will make the setting come alive on the page. If you're not in the middle of a writing project, taking a field trip can give you ideas for one. Go somewhere you would normally never go. Take notes on your observations and see what story ideas emerge.

5. **Use real-life stories.** The news, gossip, experiences of your friends, and even stories from history books can be sources for creative writing. Make notes on the story and imagine the parts you don't know. Imagine it as if you were there. What, exactly, did people see? What were they thinking? What did it all feel like? What led up to the event? What happened next? Let your imagination fill in the gaps. Or imagine that some part of it had been different. How does that change the story?

WEEK 35

HAIKU SQUARES

I love the form of the haiku in poetry because it allows whoever is writing it to find freedom within its limitations—just like a log line. Haiku is a traditional form of Japanese poetry, consisting of three lines and seventeen syllables, broken into lines containing five syllables / seven syllables / five syllables. Haikus, which rarely rhyme, often have seasonal references and two juxtaposing images. Within their small space and despite strict guidelines, they allow for maximum emotional expression.

The classic haiku "The Old Pond" by Matsuo Bashō reads:

An old silent pond . . .

A frog jumps into the pond,

Splash! Silence again.

Haiku Squares

To give our haikus a visual structure, create a haiku in the space on the next page or in your sketchbook. In the first quadrant, write your first line (five syllables). In your second quadrant, write your second line (seven syllables). Your third quadrant is visual only, a space for you to illustrate the two lines. How do the images of the first two lines interact? What feeling are you left with? Let your drawing serve as a visual thought between the lines, a time to pause and reflect. In the fourth quadrant, return to the poem and draft the final line of your haiku (five syllables).

WEEK 36

SONGS AND STORYTELLING
PART ONE: DISCOVERING NEW
WORLDS THROUGH SONG

After a decade of trauma, my therapy was based in the world of theater, art, writing, dance, music, and whatever else I could use to express myself appropriately. The arts provided a way for me to communicate whatever felt too painful and overwhelming to share in other ways. They also helped me process what I was feeling, providing mediums where I could still engage with my community, reach out to others, and make a difference in this world by utilizing my passion. Arts were my way of connecting with the world, sharing my story, and spreading my message that hope, strength, and beauty can be found in whatever life brings you. To find myself again after so many medical interventions, I painted, I danced, I wrote, and I sang. But it

was the act of writing and putting those words to music that allowed me to accept my body again—a body vastly different from the one I grew up in. Songwriting was my therapy, my safe way to express all of my unwieldy emotions, my path to finding my voice again. Within a month of starting, I had written over thirty songs.

Find your Story-Song

Have you ever heard a song on the radio that resonated with you, or with a certain time in your life? Did one song remind you of a terrible breakup, or your first kiss, or that party you just couldn't stop dancing at? Today, find that song and listen to it, reliving in as much detail as possible the memory it evokes. Next, write about the memory, giving it a new life on the page.

Song: _____

Memory: _____

Now, pick three different songs. (Make sure at least one of them has lyrics.) Play each song, one after the other, and feel the ambience that each song creates. What space, room, or habitat do you imagine? What tones do the instruments and harmonies create for you? From this audible landscape, describe the physical space of three environments. Design a world for each song as the music plays and either write about them or draw them in the spaces below.

Song 1:

Song 2:

Song 3:

WEEK 37

SONGS AND STORYTELLING
PART TWO: STEPS TO SONGWRITING

Now that you've spent time actively listening to music and reflecting on what resonates with you, you are ready to embark on the process of writing your own song. Don't be daunted. Songwriting is a great way to find a framework for the story we want to tell. You don't have to consider yourself a musician, poet, or lyricist to write a song—just take it one baby step at a time.

Song Structure

No two songs are exactly the same, but many popular songs rely on a basic framework organized by verse, chorus, verse, chorus, bridge, chorus. To create your own song, explore this classic song structure.

Chorus: A chorus repeats between verses with the same melody and the same words; it often sums up the emotion of the song.

Verses: The verses tell the story of the song. Each verse has the same melody but different lyrics. A verse takes us deeper into the feelings or situation that created the feelings in the chorus. Most songs have three or four verses.

The bridge: Bridge sections contain new material and appear late in the song, usually appearing only once or twice, often in place of a verse and usually leading into the refrain. The bridge is a unique moment in the song, with a different melody and lyrics from any other section. It often serves as a turning point.

Step One: Breath and Body Work

Centering our minds and bodies puts us in a clear and honest place that helps facilitate songwriting.

BREATH

Sitting down, pay attention to your posture. Lengthen your spine and inhale, holding your breath for a few seconds. Release your breath and sigh. Inhale again, holding in your breath for a few seconds. This time, as you exhale, release an audible sound.

BODY

Stand up, reaching to the sky. Bend down, reaching to the floor. Walk around the room to get your juices flowing. Notice the inner world of experience. Notice your thoughts and pay attention to how your body feels.

FREEWRITE

Set a timer for five minutes. Open your sketchbook and begin to write, keeping your pen moving no matter what and writing down words, phrases, and questions that emerge.

Free-sound

Set a timer for three minutes. Using your breath work and vocal cords, vocalize your feelings freely. Express, move, and sing how you are feeling, using sounds, words, phrases, physicality, or whatever you need to release any leftover tension or connect with expressions of your honest experience. Don't hem yourself in; find ways to exaggerate the honest feelings that exist within you. It might help you open up if you find a space where you have privacy.

Step Two: Write a Song

Finding a Topic

Arrive at a clear head space, noticing the feelings of your body and feet, your breath, and your gut. Ask yourself questions to guide your writing and lead you to the intention of your song: What's important for me to share? Is there a story I want to tell? What do I love? What do I want to create? What do I want to let go of? What empowers me? What are my values? Goals? What message do I want to remind myself of?

CRAFTING LYRICS

How do you write lyrics that come from your heart and are original? How can you avoid clichés, like tears "falling like rain" or someone who is "hard as nails?" How can you craft compelling rhymes that feel unexpected? Listen to a few songs and keep your ears out for phrases you hear often.

Try to come up with out-of-the-box rhymes and avoid rhyming words like "fly" and "sky" or "heart" and "apart." Look through an old book, dictionary, or encyclopedia to find words that you don't typically use. Notice what vowels they use, what they sound like, to keep your word toolbox fresh. Don't go with the first few rhymes you think of. Push yourself to think of words that don't even make sense in the context of your thoughts. You never know how that rhyme might strike a new chord (no pun intended!) in the context of your song.

To really go out of the box with what you would usually write, purposely listen to a variety of musical genres—especially types of music you don't typically listen to. You never know what will pop out at you.

Keep your ears alert for unique phrases. For example, I've always been inspired by the lyrics Joni Mitchell sings in "Song to a Seagull."

And hunger is human

And humans are hungry

For worlds they can't share

My dreams with the seagulls fly

Out of reach, out of cry

Consider your everyday experiences. What has happened lately that has brought out a strong emotion in you, an emotion you'd like to write about and explore more? Use that emotion to write lyrics. Start with freewriting and don't monitor yourself. Then, as you continue to freewrite, play around with metaphor and simile. When you get stuck, try singing whatever thoughts are coming to your mind out loud, and then write out those thoughts. Putting a tone to your thoughts might help you see them in a new light.

When coming up with a theme or tone to ground your song, think about what has happened in your life. Have you experienced love, loss, gratitude, wonder, or rebirth? What was unique about that experience to you? Do some freewriting and paint a picture with your words.

Now set limitations. For example, you can challenge yourself to only use words that have a certain number of syllables, or forbid yourself from using any word containing the letter "i." Placing restrictions will inspire you to reach for words that you might otherwise forego and avoid specific words that you typically go to.

Another way to shake up your writing process is to go through some of the journal writing you've done so far. Print out or copy certain passages by hand and cut up lines randomly to rearrange them. You can also cut out sentences from magazines or newspapers to make new combinations of lyrics for your songs. Aim for three four- to eight-line verses and one four-line chorus, as well as a four-line bridge.

Review and Develop

Now that you've recorded or written parts of your song, spend time reflecting on what themes emerged and shifted as you wrote, sang, rhymed, and moved. How can you develop the song more to tell the story you want to tell?

Notice the structure of your song. For instance, is it abstract or is it focused? Is it personal or is it third person? Does it keep the same tenses and perspectives throughout or do they change? Edit your lyrics to make your message consistent and clear.

WEEK 38

MINISTORIES ON INCHIES

I've dubbed art that can fit onto a one-inch by one-inch square an "inchie." I love creating inchies because they are manageable creations and there is the option to keep them as is or make them part of a larger project. You can create an inchie in the form of a micropainting whenever inspiration strikes. You can create an inchie to wear as a pin or to place on a greeting card. Or you can create twenty inchies to display together on a large canvas. It's up to you.

Inchies can be looked at as ministories. They can capture a moment and serve as little reminders that we don't need to know exactly how our story will go. We just need to know what the next step is. So this week take life one inchie at a time.

Inchies

MATERIALS TO GET STARTED

- Canvas paper
- Acrylic paints
- Felt
- Puffy paints
- Fabric scraps
- Little embellishments like sequins, buttons, and stickers
- Magazines
- Glue gun (or any glue)
- Scissors

TO MAKE INCHIES

Take a sheet of paper and paint an abstract background on it. You can also collage the background with tissue paper and magazine images.

With a ruler, measure out one-inch by one-inch squares from the canvas paper you've created. Using a pencil, mark the squares. With scissors, cut them out.

Once you have your squares, begin decorating. Find a word or small image in a magazine to place onto your inchie as the center-piece, or use felt, fabric, and embellishments to create a scene around your word or image. Glue everything into place. Any adhesive will work. (I've used Elmer's, a glue gun, a glue stick, even Mod Podge. If

you aren't familiar with Mod Podge, it is an all-in-one base, glue, and finish that dries clear—a secret weapon for collage and decoupage. You can find it at any craft store.)

Once you've repeated this process for several inchies, decide how you'd like to display them. Here are some ideas:

- Place one inchie on a greeting card cover.
- Arrange nine inchies in a grid for a piece of artwork.
- Arrange five inchies in a horizontal line to read as a storyboard.
- Stick inchies in random places in your sketchbook.

Play around with arranging your inchies and notice how arranging them in certain ways makes you feel. By juxtaposing one inchie with another, how does the message change? Do certain colors complement or clash with each other?

CREATING BACKGROUNDS FOR INCHIES

You can create each inchie on colored (or any) paper, or you can create a larger painting that you will later use as a background for many inchies. When creating the background, take out rolling stamps, brayers, tissue paper, and stains to move the paint around and create textures. When the background has dried, cut it into one-inch strips vertically and then horizontally. Some of these squares turn out interesting and beautiful just as they are.

WEEK 39

IMAGES AS INSPIRATION

Every day this week, set a timer for ten minutes to complete these prompts.

Day One: Ekphrasis

Find a piece of art that inspires you. Does it evoke a certain feeling, bring up a memory, or connect to something in your life? An ekphrastic poem is written in response to a work of art. In addition to describing the artwork, it captures the feelings and imaginative connections a viewer makes. In essence, it's a work of art about a work of art.

For our purposes, anything can serve as the inspiration piece for this poem. Just look around you. Once, I unwrapped a Life Savers

candy and was struck by the deep ruby shade of its color, as well as its smooth, circular shape. As I looked at the Life Saver, I began to consider larger questions and concerns. It brought up ideas about salvation, religion, materials, and helping others. It made me realize my passion for singing was a way to be here, alive on this earth right now. It might have been a quotidian object, but I was inspired to write a poem. Can a simple object in your everyday inspire you to write a poem and take on new meaning through your composition?

To Write an Ekphrastic Poem

1. Select a piece of art and describe what you see. Consider various visual elements of the art: colors, shapes, lines, composition, and shadows.

2. Whenever your description sparks a feeling or memory, include it.

3. If you feel overwhelmed, focus on a single detail of the art: a figure, a specific color, or something lurking in the background.

Day Two: Pick an Image That Contains Any Kind of Transportation

Write about a ship or other vehicle that can take you somewhere different from where you are now.

Day Three: Dating a Character

Find a new painting, image, or work of art featuring one person (for example, Leonardo da Vinci's *Mona Lisa*), and write a story in which you are meeting them for the first time on a dinner date.

Day Four: Eye Contact

Find a new painting, image, or work of art featuring two people, and write a story in which the two people see each other for the first time.

Day Five: A New Frontier

Find a new painting, image, or work of art featuring an abstract design. Write a story in which a rocket ship is on its way to the moon or a distant galaxy. The abstract piece of art that you have selected is this new landscape.

Day Six: Bright Spots

Find a photograph or painting. What is the brightest part of this picture? (However you interpret "brightest.") What happened ten

minutes before this image? What will happen ten years from now to the people, places, or objects in the image?

Day Seven: Family Photo

Select a favorite family photograph. What memory does it bring back? Focus on the moment that the photograph captures, trying to recall sounds, smells, and other sensations, as well as what things looked like. Then write about it, recreating the scene.

Takeaways

Stories are meant to be told, heard, shared, passed on. When, what, and how is up to you. Think about what you've learned from stories and the stories that you have to offer your community.

Where are the human interest stories in your newspaper? Are there storytelling events or open mics in your area? What do people talk about at your local coffee shop? Do people tell stories at holiday parties or family meals? Are there places in your area that could use more stories? How can you share yours? Here are some ideas to get you started:

- Arrange a book swap with a friend.

- See a community theater play in your area. Volunteer as an usher.

- Think about the hero's journey. Is there someone you know going through a struggle? Can you act as a mentor or friend on their journey?

It would be easy to list twenty ways to share your story through technology and social media. But can you find new (old) unplugged, unwired ways of sharing your story? The tradition of oral storytelling dates back centuries ago. Talk with family, friends, or elders and ask them questions about how they grew up, what their favorite school subjects were, what they loved doing most outdoors. Where did they hear their stories?

Take time to share your own stories with children. Can you volunteer at a library and read a children's book? The next time you go to a group gathering or party with friends make a point of having each person tell a story of events when they were younger to keep the tradition alive. Even better, have them share a story about a great-grandparent.

Do you collect postcards or hold onto birthday cards? What about a box of photographs that you randomly add to? You can even gather a collection of magazine images for your next gathering. Use this visual

treasure box for guests to pick out one photo, or one card. Gathered around a table, take turns sharing the stories you and your guests have created about the photos or cards you've chosen. Storytelling, after all, enlivens every gathering and brings us all together in a joyful, meaningful way.

Flowers I have encountered so far on this journey:

The world has enough beautiful mountains and meadows, spectacular skies and serene lakes. It has enough lush forests, flowered fields, and sandy beaches. It has plenty of stars and the promise of a new sunrise and sunset every day. What the world needs more of is people to appreciate and enjoy it.

—MICHAEL JOSEPHSON

gratitude

There I was, taking my final bow after ten years of medical hurdles. I had done it. I had written and performed a one-woman musical about my life: how I literally lost my stomach (when it ruptured in the operating room) and gained a story.

It was a big deal to finally compile all of the journaling I had done for six years while unable to eat or drink into a kind of script of my life. Completing my show was a full-circle moment, filled with show-biz razzle dazzle. After nearly losing my life at eighteen years old, I was now singing and dancing about it, and hopefully inspiring others. My musical marked the beginning of things to come.

Even though I had regained medical stability, stamina, and spirit, I still had things to overcome: an ostomy I wanted to reverse, and a fistula—which is an opening in your body after surgery which should have stayed closed—that refused to heal. Thankfully, I had the option of getting elective surgery to reverse my ostomy bag and heal the fistula in the process.

I went in for this surgery—my twenty-seventh—four days after I premiered my show in New York. Three additional surgeries, a few catheters, and two months at Mount Sinai Hospital later, I woke up with more problems than I went in with. I was overwhelmed, waking up in the hospital and once again faced with a brand-new medical team working to understand my lengthy medical history and get to know me.

I was a person! How could I go back to being a patient? Could my nurses and doctors fathom that I had starred in a musical about my life just one week before this? My medical history was so jaw-dropping that doctors usually assumed the hospital *was* my life. They couldn't comprehend that not only was I able to do *normal*, functional things, but also *extraordinary* acts in spite of my circumstances. My one-woman show was a triumph of the human spirit: my great comeback. Now all of that work seemed to be erased in a heartbeat, as though everything I had accomplished was just a dream and now I was waking up.

I ended up staying in that hospital for almost three months, once again unable to eat or drink indefinitely. So how did I get through it? I learned how to find and practice gratitude in a whole new way.

WEEK 40

VISUALIZING GRATITUDE

This week make a collage of all the images that the word "gratitude" brings up for you. To get started, make a mental inventory of your earliest memories, going through life milestones, events, holidays, interactions, people in your life, and beyond. How has your relationship with gratitude shifted as you have grown? What does the term evoke for you now? For me, images that come up are autumn leaves and harvest bounties, Thanksgiving tables, and strangers smiling at each other on the street.

When you are feeling downtrodden or discouraged, look at your collage and remember that not only is there so much to be thankful for, but that you hold within yourself the power to harness gratitude through just a bit of creative thinking.

To Make the Collage

Flip through magazines, pamphlets, and old photo albums, culling the images, words, colors, and shapes that instill feelings of gratitude within you or that evoke memories in which you felt grateful. Using scissors, cut them out. With glue or gesso, paste them onto a blank page in your sketchbook.

WEEK 41

GRATITUDE LISTS A TO Z

Every day is an opportunity to remember the things that make us grateful. After my ordeal, it took a while to gain back the use of my hands. But once I was able to write again, I spent every day making gratitude lists. Guided by the alphabet, I assigned one thing to be grateful for to each letter. Even on the hardest days, I found that by the time I got to "Z," I had at least a few things to smile about.

Soon, my alphabetical list turned from "A: Almost walked. B: Better heart rate. C: Coughed less." to "A: Awesome walk outside. B: Best afternoon ever. C: Cheerful spirits today." It was amazing to see each day slowly improve and feel myself gradually claiming owner-ship of my world again.

By creating these lists, I was able to give myself twenty-six powerful reasons why I shouldn't give up hope each day. When all else felt lost, I had those twenty-six bulleted thoughts to hold me through until tomorrow. By recognizing what I was grateful for, I began to understand who I was and what I stood for. When I started my lists, I started to feel myself materialize back into the girl I knew before my coma. This time, however, I was equipped with a deeper wisdom and a vivacious new desire to discover the world.

Building Your Alphabets of Gratitude

Every day this week, use the alphabet to list twenty-six things you are grateful for—one item or thought for every letter. By the end of this week you should have seven A to Z gratitude lists. Look over what you've written. Are there any specific words that pop out at you? Do certain words bring up different images, memories, senses, or physical sensations?

Dedicate a page in your sketchbook to three of the most important words, ideas, people, or items that you've listed. Do these ideas come from a larger place? What do they tell you about what means the most to you?

WEEK 42

GRATITUDE FOR ANXIETY (THANKING UNCOMFORTABLE EMOTIONS)

What's the point of feeling things if they can't show us something about ourselves? Emotions are like arrows, pointing to our needs and desires and showing us where we need to go next. But some emotions don't feel as good as others. I'm sure we would all choose happiness, excitement, and humor over hurt, disappointment, and sorrow. But what if we find ways to be grateful for the lows as much as the highs? What do "bad" emotions teach us about ourselves? They show us that we need to pay attention to and nurture our hidden hurts; they show us that something in our lives needs to change. If we acknowledge the thorny patches that line our detours we might even find flowers.

This week embrace uncomfortable sensations. Think about what new discoveries and experiences have provoked unpleasant feelings like fear, uncertainty, and anger.

Prompts

Here are four writing exercises to help you greet your unpleasant emotions with gratitude.

1. Write a dialogue between your negative emotion and yourself. Let the emotion speak to you. Imagine what it would say to you if it could talk. How would you respond? Use your nondominant hand to write out the lines of dialogue coming from your emotion and write your response with your dominant hand. (Why write at all with your nondominant hand? It might be incredibly challenging, but doing activities with our nondominant hand lessens our control of the outcome. Relinquishing control allows us to work from our gut. Our writing can come from a more intuitive place without our inner critic hijacking the process. If you're intimidated by writing with your nondominant hand, start by making a nice hot cup of tea with your nondominant hand as a warm-up.)

2. Set a timer for two minutes and freewrite about the bodily sensations that a negative emotion provokes. Here's a snippet of what I wrote: "I am so frustrated. My brain hurts. Like a whirlpool, a big knot of tension accumulates in my chest."

3. Write thank-you notes to your negative emotions. What can you thank your ugly emotions for? Maybe frustration and fear have helped you discover something crucial about your needs. Perhaps your anger clued you in to the parts of your life that you needed to let go of in order to find happiness. Write traditional thank-you notes as you see fit, or see below for some creative inspiration.

 Stamping: When we feel ugly emotions, sometimes it feels relieving to throw a pillow or hit a wall. So what better way to thank those emotions than with a stamped card? Using ink or markers, dip or draw on your fingertips and stamp them onto a card. For every fingerprint, assign a negative emotion and then release it. Alternatively, make potato stamps. Cut the potato in half. Draw the desired shape onto the surface of the potato using a pencil or marker. Cut around this shape with a kitchen knife, leaving the design so it is raised on the surface of the

potato. Pour paint into a small bowl and dab the potato in the paint, not too heavily. Stamp the card, releasing the emotion every time the potato meets the paper.

What you resist persists. So make a card to thank those persisting emotions. With a white crayon simply write a message, then paint over it with watercolors to reveal your message.

4. Write an ode to your emotions. Try to think of four different negative emotions that weigh you down. Bring them together in a poem that celebrates their purpose. This poem can be rhymed or unrhymed, but rhyming allows us to exert a sense of control that can feel empowering, so why not give it a shot. I've included an excerpt from my own ode on the next page, following an A/B/A/B rhyme scheme in which every other line ends on the same rhyme (I've bolded the "A" rhyme and italicized the "B" rhyme in the first stanza). To guide my content and provide structure, I've begun each stanza with "Thank you." Refrains, repetition, and rhymes provide a key framework to guide expression. When you are getting started writing poetry, don't be afraid to lean on these devices to help you along.

Here is an excerpt from a poem I wrote called "Thank You":

Thank you, boredom, for the **place**

To sit with only and just *me*

To clear out enough empty **space**

To search my soul *curiously*

Thank you, anguish, for the pain

That brings me back to recollections

Allowing me to visit again

My past and make insightful connections

Thank you, stresses, for presenting

Challenges to overcome

Breathing you out is preventing

Me from freezing, going numb

WEEK 43

PRESENCE AND GRATITUDE

When my anxiety sucked me into the trauma vortex, I found that grounding myself by focusing on my sensory experiences and flexing my go-to resilience tool, gratitude, was an effective way to bring me back to the present moment. Each of us has things to be thankful for. This week we'll explore the relationship between gratitude and presence and learn to look for the positive wherever, however, and whenever.

Listing Gratitude by Sense

For each of the five senses, list three things you are grateful for.

I'm grateful that I hear:

1. _____

2. _____

3. _____

I'm grateful that I see:

1. _____

2. _____

3. _____

I'm grateful that I smell:

1. _____

2. _____

3. _____

I'm grateful that I feel:

1. _____

2. _____

3. _____

I'm grateful that I taste:

1. _____

2. _____

3. _____

Gratitude Totem

Checking in with our sense of touch is a wonderful way to inspire gratitude. Think about all the things you touch in one day that feel good. The softness of fleece? The warmth of water running over your hands?

Physical objects act as handy tools that remind us of our bodily presence and help us check in with ourselves. This week select an object that you can hold in your hand: a stone, a crystal, a rubber ball. Pick something that you like, whether you like it because it's pretty, because it feels good, or because it reminds you of a special place. This will be your gratitude totem. Carry it around in your pocket, wear it, or leave it on a table or desk where you can see it and touch it at any time.

Remember, the sensations in your body can change at any moment. Any time you hold the item, it may feel slightly different than other times. Use the totem as a way to tap into the moment and think about one thing you are grateful for. At the end of the day when you take the totem out of your pocket or off of your body, or leave it behind on your table or desk, take a moment to remember the things that you were grateful for throughout the day. When you hold the totem again in the morning, repeat this process to remember what you were grateful for the day before.

Decorating Your Totem

Your gratitude totem should feel personal and totally yours. If you would like, use paint or permanent markers to add color or decoration. You might incorporate designs, words, or symbols—anything that makes the object feel more like you.

If you love the way your totem looks as is but want to flex your artistic skills, sketch it in the space below or in your sketchbook.

WEEK 44

GRATITUDE FOR KNOWLEDGE—
LEARNING WHERE THINGS COME FROM

After I returned from the hospital, I yearned not only for answers to questions about when my digestive system would be reconstructed or when I'd get my life going again, but also to learn more about the world. I had a tremendous thirst for knowledge, and I wanted to expose myself to diverse interests, meet people from all over the world, and study a wide array of subjects. Eventually, I went to college at twenty-five years old, but for seven years prior I had to find creative ways to satisfy my longing to learn.

When we educate ourselves about the history of objects, places, and people, we make space for new levels of gratitude, allowing ourselves to appreciate where things come from, how they are made, and

what they are used for. Do you know how much work goes into the food that is on your table? Or the craftsmanship and innovation that went into the creation of the table itself?

The musical *Working*, based on the Studs Terkel book of the same name, incorporates song interviews with people from different regions and occupations. In one song, a mason sings about the work that goes into building a house and the pride he takes that in a hundred years people will still see his work. Every song gives details about someone's occupation and also reveals the personal stories behind the work that they do.

Learning about what someone does—their daily tasks and motivations—allows us to understand, and therefore become grateful for, their work. Through that one song from *Working*, I became aware of all of the work that goes into building a house, and had a new appreciation for the structures I had taken for granted.

Appreciation for Everyday Objects

To gain appreciation for the objects, occupations, and places that comprise our world, make a practice of listening. Ask your friends what they do at their jobs—the nuts and bolts of their work—and seek out podcasts about history, inventions, or how something is made. I love podcasts about invention because learning about the many trial-and-error attempts throughout the history of invention

sparks my own creativity and gives me the confidence that—well, Thomas Edison said it best: "I have not failed. I've just found ten thousand ways that won't work."

This week find something you use every day and learn about its history. Here are some resources that I use:

- **Brainpickings.org:** A website (with a podcast of the same name) from Maria Popova, a writer who has created an "inventory of a meaningful life."

- **Invisibilia:** An NPR podcast about the invisible and underappreciated forces that guide our world.

- **Stuff You Should Know:** Who gets to name continents? How did Jim Henson work? This Stuff Media podcast is a great portal into history, facts, and ideas.

- **Radiolab:** This is a popular podcast from WNYC that is devoted to "investigating a strange world."

- **TED Radio Hour:** A curated podcast on some wonderful ideas from TED Talks based on a weekly theme.

- **TodayIFoundOut.com:** Visit this website, run by the Today I Found Out team, every day to dive into a random fact or period of history you never knew about before.

- **Survivalinternational.org/uncontactedtribes:** This website run by the charity Survival International is a beautiful collection of videos, pictures, and stories of uncontacted tribes that still exist, scattered all over the world.

- **InterestingFacts.org:** There are lots of great places to get odd information. InterestingFacts.org is among the best researched and most diverse websites for this.

Deep Dive on an Object

Commit to learning the history behind one object that you use every day. To stop yourself from going down an internet search rabbit hole, commit to learning the object's history in just seven days and not getting sidetracked by other things your research may inspire you to want to veer off course and investigate. Jot down what you have learned about your object in your sketchbook or the space provided.

Object: —————————————————————————————

—————————————————————————————————

History: _____

Approach the object now, engaging all of your five senses as you use it. Did learning about the history behind the object make you use it with any new awareness? How was the experience different?

Challenge: Art from Everyday Objects

Making art should be an immersive experience that involves research, resourcefulness, and repurposing. This week, as we engage with the histories and backstories of our favorite everyday objects, spend some time thinking about their artistic potential.

Here's an exercise that involves coffee grounds, something most of us encounter frequently and throw away or compost without much thought.

Painting with Coffee

MATERIALS TO GET STARTED

- Coffee grounds (used)
- Bowl
- Water
- Pencil
- Paper
- White crayon
- Paintbrush
- Newspaper

To Paint with Coffee

Put two tablespoons of coffee grounds in a bowl and cover them with water. Let them soak, from five minutes to overnight (the longer the grounds steep in the water, the darker the paint will be).

Using a pencil, sketch whatever you like on a piece of paper. Outline the drawing with white crayon. Press hard on the crayon and fill in as much of the outline as possible.

Dip a paintbrush in the coffee grounds-water mixture and paint the mixture across the paper. It doesn't matter if some of the grounds get onto the paper. The wax in the crayons will resist the coffee dye and keep the color of the crayon. Let the picture dry.

If there are sections of your painting that you would like to be darker, dip the brush in the coffee mixture and paint over those parts once more. You can also use your fingers to paint the coffee onto the paper.

To dry the picture, lay it flat on newspaper.

Note: Coffee is only one natural stain or dye. Tea also creates stains. To use tea leaves for this, let them soak from five minutes to overnight to (like coffee, the longer they steep in the water, the darker the paint will be). The gills and dark parts of mushrooms produce some amazing shades of color as well.

WEEK 45

GRATITUDE FOR THE UNKNOWN

At the same time that we can practice gratitude for information and knowledge, we can find gratitude for what we don't know and can't know. When I woke up in the ICU and could only see the ceiling and hear the beeping of IV pumps, I was devastated, but mostly confused. I felt like I had woken up in someone else's life. Everything felt strangely new. I was like a child coming into the world for the first time and I had to start from scratch. But starting from scratch is where I discovered the first seeds of newfound gratitude. And when I viewed my life as a blank page, I found many opportunities for creativity. Life, after all, is a dance of certainty and mystery; when we write on a blank page, we leap into the unknown.

Collecting and Decorating Fragments

This week collect poems and song lyrics about the unknown. Poets have embraced the mysteries of life since the beginning of time. When I search for solace in the face of detours, I look to certain poems that celebrate the journey of life and all of its uncertainties: "Moon for Our Daughters" by Annie Finch, "Hope is the Thing with Feathers" by Emily Dickinson, and "The Road Not Taken" by Robert Frost. Are there pieces of literature or quotes that speak to you? Print out poems, quotes, and song lyrics and paste them into your sketchbook or write out certain lines that stick with you. Feel free to decorate and embellish the quotes by drawing with colored pencils or pens or pasting collage bits to the page.

Embracing the Unknown Creatively

Here are three other ideas for activities to get you comfortable with (and grateful for!) uncertainty.

1. **Tai chi.** Tai chi is a Chinese martial art of slow meditative movement for relaxation, balance, and health. Tai chi combines mental concentration, slow breathing, and dance-like movements to increase life force energy. Each posture flows into the next without pause, ensuring that your body is in constant motion. Tai chi also involves

learning how to balance and remain upright in the face of uncertainty in your ability to do so. You can find tai chi classes online if taking them in a local studio is not an option.

2. **Improv.** You don't need to consider yourself an actor, a writer, or even funny to do improvisational comedy. Improvisation teaches us to feel more comfortable when dealing with uncertainty; it forces us to keep going even if we don't know what to expect, and to enjoy the anticipation. In improv, everything that happens onstage is a gift we can use to further the scene. There's no script—anything you say or do is right. You gain the excitement, reward, and adventure of playing with unknown outcomes. Look online or check with your local community theater or library to see if any improv classes are being offered near you.

3. **Play a mysterious game**. Play a game—a whodunit or a puzzle—that embraces the feeling of not knowing. Look up some brainteasers, optical illusions, logic puzzles, and riddles, and savor the puzzlement you feel. I like to go online to find brainteasers. You can also search for ambiguous images, or create a mystery puzzle yourself

by making an ambiguous stain in your sketchbook with spilled tea, a blot of ink, or a splotch of leftover paint. Then share it with a friend and have them interpret what they see. Find a few people to ask what image is forming for them. Tell them this image has no title and that the name of the image lies in the eye of the beholder. Be reminded of what it was like when you were a child staring up at the clouds, interpreting their shapes as bunnies or boats.

WEEK 46

UPCYCLING AND REPURPOSING

Have you heard of repurposed art or upcycled materials? Upcycling is the process of turning something considered to have limited or no use into something that is full of worth—whatever "worth" means to you. It is a form of recycling where instead of turning waste into new materials, you take a product that you would otherwise throw away and give it a new use in life. Rather than recycle using a recycling bin, you can use your creativity to update and renew old items.

Upcycling is a great way to practice gratitude because it forces us to appreciate the value of an item and inspires us to think creatively about purpose. It is also a way to show gratitude to the environment; through upcycling we can embrace a waste-free mindset, throw out

less trash, and practice sustainability. In your upcycling or repurposing practice, you can utilize anything. Some things I have used in the past include brochures, business cards, old calendars, receipts from cash registers, food wrappers, kitchen foil, and sheet music.

Repurposing Food Packaging

When I was unable to eat (but voraciously hungry), I kept a watchful eye on all of the delicious foods I couldn't wait to devour. To me, the brightly colored cereal boxes and shiny bags of potato chips looked like modern art. Once I could finally nibble on the snacks I had ogled for years, I wanted to memorialize the packages and wrappers they came in.

If I saved every container and wrapper of things I've eaten since then, my house would be quite a mess. But giving some of these containers a new life through upcycling became a way to show gratitude for the joy that they brought me. The more time we spend with an object, the more opportunities we have to see it in new ways, and the more gratitude we feel for the object, for its role in our lives, and for our own circumstances.

Making a Shadowbox Vision Board

MATERIALS TO GET STARTED

- A container with multiple slots (chocolate box, cracker tray, cookie tin)
- Paintbrush
- White gesso mixed into small container of water
- Magazines
- Scissors
- Glue
- Paint (optional)
- Fabric (optional)
- Beads (optional)

To Make Your Upcycled Vision Board

Select a snack container that has multiple slots. Think about an ice cube tray, with its grid-like setup and multiple sections. A good example might be a heart-shaped chocolate box, a package from assorted crackers, or a blue box of Dutch butter cookies.

Once you find your ideal package, dip a paintbrush in a small bowl of white gesso mixed with water and paint the entire tray (this primes the container to become your canvas). Let the gesso dry overnight.

Flip through old magazines and use scissors to cut out words or photos that inspire and encourage you—these could be words like

"hope" or "gratitude," or abstract images that convey these messages. What are you thankful for? What are you looking forward to?

Using glue, fix the magazine cutouts into the different slots of your package. Each slot can contain a different vision, a different goal, or a different message of gratitude. Feel free to get creative, using colored paints, fabric, or beads to decorate your work of art. You don't need to fill every section at once.

Upcycling Inside

After being discharged from the hospital and moving into a new house, what I missed the most was related to my old kitchen table. It wasn't the table itself that I missed, it was the marks I had made on it—evidence of life, of presence. In an old journal entry I wrote about what made that table feel so personal and integral to my identity.

> I started thinking a lot about my old house last night. What makes a house a home? The lazy Susan with the big bowl on it for bills and random papers? The paint marks under the table? The sounds of Gabby's paws on the peach tiles stained with dirt in between each cold square? Doing my homework sitting alone at the kitchen table eating a homemade lean hamburger and getting food stains all over the lined paper. A kitchen table can say so much—I could write sagas just on that

big white sturdy piece of furniture. All six of us sitting around it in a warm familiar circle—I think kitchen tables should always be a circle. It was shaped like a friendly gazebo, a unique shape within the structure of our home, declaring the kitchen special and safe territory, a place of peace, bonding, and good family-nourishing times.

The fundamentals of upcycling are not limited to the material world. Upcycling is a mindset that we can apply to our thoughts, perceptions, and memories. When we contemplate the multipurpose nature of items or objects, we engage the mentality of upcycling to get in touch with gratitude. We can show our appreciation for a simple structure, and the memories that surround it, by cherishing it as it is—flaws and all. Instead of upcycling it by making new marks on it or by physically repurposing it, we can spend time thinking about its emotional use.

This week look around your home, pick an everyday object, and spend some time journaling about its physical purpose, its emotional purpose, and the relationship between them.

WEEK 47

GRATITUDE FOR OTHERS—
ORAL HISTORIES

After my trauma of being in a coma at age eighteen, I wanted to know how my grandmother grappled with her own trauma, surviving the Holocaust, at the same age. My beloved grandmother, who passed on her sewing skills to me, had passed away while I was in a coma, so I compiled a collection of oral history interviews with my grandmother's surviving relatives around her age. I asked about their memories of the Holocaust and immigration; I wanted to explore transgenerational trauma and post-traumatic growth. I became a detective, stringing together a family narrative, and found within it a map for my own healing.

I began collecting an oral history of my grandmother by asking my family members simple questions about her life. How did she

celebrate good times after her life had been torn apart? Could I, as her granddaughter, do the same?

To get a full picture of her own resilient path, I started a lengthy, yet ultimately life-changing process of research. I asked my family and friends for information and I looked online for records and dates that were pertinent to her life: Holocaust timelines and information about life for immigrants in Brooklyn, where she lived. Contacting libraries and digging through archives, I tied together the threads of her life and slowly turned the fear of losing my grandmother into the joy of preserving her story.

When I couldn't find the answers in my family or at the local library, I embraced oral history by searching for people outside of my circle and documenting their memories. Thanks to Facebook, I tracked down three generations of relatives in seven countries, conducted hours of interviews, and transcribed hundreds of pages of notes.

By interviewing my family members, I recovered the threads of a history that might have been forever lost—threads that created a bridge, allowed healing, and gave insight into our identities. There is so much we can learn from those who came before us and from those who are still with us if we are willing to reach out and listen. Family legacy and lore can provide key insights into who we are and where we come from. Uncovering our roots makes the tapestry of our lives both clearer and more intricate.

I found gratitude in the process of learning about my roots and how my family had survived and thrived through unthinkable traumas. Looking closely at my grandmother's life not only taught me resilience to survive trauma, and thrive and celebrate life when times are good, but inspired me to speak, perform, write, create, and share my own story in the hope that it can make an impact on others the way that her story made an impact on me.

This week interview a person or multiple people in your life: role models, people you respect or admire, or people that you feel grateful to have in your life. They don't necessarily have to be family members, but they can be.

TO GET STARTED

1. Decide which people you would like to interview and make a list.

2. Ask for permission to conduct an interview.

3. Set a date and time for the interview.

4. Prepare the questions you would like to ask and give your interviewees the list in advance.

- Focus on a single subject or event in each list of questions.

- Ask open-ended questions (these questions often begin with Who, What, Where, When, How, and Why).

- Avoid yes or no questions.

- Pick subjects for your questions ranging from life events to education, hobbies, work, relationships, and travel.

- Use visual aids when asking your questions. A photograph can trigger a memory response and one vivid memory might take your interviewee back to a whole series of events.

Innovating the Past

Oral history can inspire all kinds of creative ideas. Listen to the interview, engaging your auditory senses, and then craft a creative response to what you hear in the form of a poem, short story, or drawing. Take it a step further by taking extracts from your interviewee's answers and illustrating them in your own personalized calligraphy. Send the artwork to them as a thank-you, or keep it for your own sketchbook.

WEEK 48

THE DOMINO EFFECT

Everything good that happens in this world is the result of a chain of events. No matter the size, each event has a history. As you look at your links of gratitude, notice how what you appreciate all ties together into the fabric of who you are. The gratitude you feel in one part of your life will add energy and joy to the other areas. Gratitude is contagious!

This week we pull our inspiration from Duke Ellington, whose song "I Like the Sunrise" links one moment of happiness to the next:

I like the sunrise 'cause it brings a new day

I like the new day, it brings new hope, they say

I like the sunrise blazing in the new sky

Writing a Gratitude Daisy Chain

Try writing your own version of a song, poem, or list, that links one idea lead to another, focusing on gratitude and enjoyment and ending with a sensation in your body. As an example, here's a poem that I crafted:

I like clouds because they give us mist

I love mist because it adds moisture to the air

I love moisture because it leads to liquid forming

I love liquid in a cool drink

I love a cool drink because it coats my throat

My throat makes me feel alive when I breathe in and out

If that poem, or your own song, poem, or list, inspired an image or feeling you'd like to capture in your sketchbook or below, take a few moments to sketch it out.

WEEK 49

GRATITUDE FOR EMPTY SPACES

Fireworks can be loud and exciting, but silence can be powerful. Those moments may be easy to overlook, but if we stay still enough to listen to silence, we might hear whispers of the most profound gratitude. On my own journey, I tended to clutter up my life with noise when I was trying to avoid a certain emotion or situation.

Empty space can be a gold mine brimming with security, gratitude, and happiness if we allow ourselves to relax in it for a while. Move too fast through it, and you might miss the chance to find the gifts in silence.

This week leave a pause in your day where you may ordinarily fill it with noise. Turn the radio off. In your sketchbook or art this week

add blank space around your work. As viewers, we need space so that our eyes can relax for a second before they jump into busier sections. We need space to digest and observe what is there.

It may feel scary to let go of distraction, noise, movement, and "stuff." But we must let go of those things if we want to process our feelings. Feelings are like antennae; if something causes us distress, ask: "What do I need to look at here?" First, look at the truth, the reality. What is my role in this? Then ask, in terms of your own self-growth, "What lesson is this emotion trying to teach me?"

Sneaking in Simplicity

On my journey, I found simplicity and silence daunting, but through small shifts, I managed to sneak an appreciation for the quietness of the present moment into my daily practice. Here are some of the tricks I used to welcome more space, and more healing, into my life.

Try out one of these ideas every day this week. After you've completed each one, observe the blank space, stillness, quiet, or nothingness in it and listen for a message. How does that empty space enrich your being right now?

1. Using a pen or pencil, make one tiny dot on a blank page in your sketchbook. In the empty space that surrounds the mark, meditate on the possibility that is created by the blank space.

2. Turn off the television during commercial breaks and breathe deeply in the silence this creates.

3. During a walk outside, incorporate moments of standing still.

4. During a meal, put your utensil down in between bites and pause. Be mindful of the food you are eating, your gratitude for the ingredients, and the feelings in your body.

5. Schedule free time. Leave intentional gaps between meetings or classes.

6. Every time you are tempted to check your phone, inhale deeply instead.

7. Where else can you find a moment of empty space in your life? Try to double that moment with extra emptiness—and enjoy it! Take time to silently reflect on how pauses nurture you. Who are the people and what are the places, things, and activities that are associated with a more-is-less mindset?

WEEK 50

FINDING GRATITUDE IN SAFE SPACES OUTSIDE AND WITHIN

Last week's focus on silence and empty space helped us find bliss in the present moment instead of the quest, our future goals, or desires. This week we go further to cultivate that sense of safety we can find within us at any time. To help you visualize your own blissful space, think about what feels good for all five of your senses and journal about it. This was what I wrote, taking care to engage each of my senses:

What does "sitting in the bliss" feel like? What am I sitting on? A leaf? A leaf doesn't seem comfy enough to sit on. A snowball is too cold. What can I tuck myself into? A fleece hammock.

Sitting on something, making me feel warm and cozy. What am I sitting on? What am I surrounded by? A flower bed of clouds. That seems comfy. Pink misty clouds that smell of room spray, like harvest brew or frosted pumpkin, the buttercream of baked cookies. I love watching candle flames, smelling room sprays, touching soft fleece. That's sight, touch, and smell. I love hearing wind rustle or rainfall, and I love tasting crispy things like the burnt edge of a pizza or bread, or softer things like soba noodles.

The Four Elements

Now that you have created your safe space within, explore how you can find safety in your outer world as well, even when circumstances feel difficult.

The ancient Greeks believed that there were four elements that everything was made up of: earth, water, air, and fire. In science today, this theory has evolved into these four elements: solid (earth), liquid (water), gas (air), and plasma (fire).

How can this help you now? I felt very isolated on my surgical marathon, even when I was in a busy hospital surrounded by buzzing machines and countless nurses and doctors. But the four elements were everywhere. When I was out of the hospital, I focused on these elements all around me in the natural world, but even when stuck indoors, I looked for the four elements in my surroundings. When

I saw everything was comprised of the same earthly elements, I felt gratitude and a sense of belonging.

THE FOUR ELEMENTS I FOUND ON A NATURE WALK:

Solid (earth): The shiny green grass.
Liquid (water): The soothing pitter-patter of rain.
Gas (air): A fresh autumn breeze stroking my cheek.
Plasma (fire): The warmth of sun shining on me.

THE FOUR ELEMENTS I FOUND IN MY HOSPITAL CUBICLE:

Solid (earth): The shiny white tile floor.
Liquid (water): The liquid in the IV bags, sustaining me with life.
Gas (air): The breath I could always exhale wherever I was.
Plasma (fire): The light in my hospital room that had a rhythmic flicker.

Grab your sketchbook and a writing utensil and head out on a walk outside. Observe the elements around you and make notes on what you see. After you jot down your notes and observations, sketch or paint the elements that you encountered.

The Four Elements I Found

Solid (earth): _____

Liquid (water): _____

Gas (air): _____

Plasma (fire): _____

WEEK 51

GRATITUDE FOR IMPERMANENCE

Is there a certain memory you have of finding something in nature that only lasted a small amount of time? I remember being in summer camp and seeing a gust of wind blow through dandelions in a field. One minute they had full heads of seed, the next minute they were bare stalks. Who are we to say that art has to last forever? Aren't we only here for a short time? Let's find a way to make this very moment count. Today, give gratitude for what is ephemeral.

When making art, I don't worry about what has archival value. Life is fleeting, and we all dance on the border of permanence and change.

Incorporating Ephemera

This week look all around you and notice the natural cycles of life. Challenge yourself to use as many ephemeral materials as you can— grass, twigs, wood, leaves—what else will not last on your canvas? Using an object in a new way (even hiding or disguising it) is a way to find new sources of beauty and gratitude.

A jar of Mod Podge is all you'll need to keep your ephemera in your sketchbook this week, creating some wonderful moments and art in the process.

Incorporate Ephemera into an Existing Collage or Painting-in-Progress

Add ephemera to a painting or collage you are working on and then top with Mod Podge or gesso. The ephemera will become a part of the piece or collage. If you cover the ephemera with white gesso (rather than clear), only its shape will be visible.

Make Art with Natural Materials—And Let It Go

Creating art in nature provides endless possibilities. I love doing so because it's simple, fun, and free, and it gets you exploring while using your imagination. As an added bonus, I always feel calmer after spending time in nature. For this activity, simply get outside and create with what you have. Once you are done arranging your art, photograph it and then leave it exposed to the elements of weather and time. Don't bother using any kind of adhesive, plaster, or Mod Podge to fix your creation into a set place. This is art meant for you to experience in this moment in time. Some ideas include drawing with chalk outside, making sculptures in the sand, or painting the ground with fallen leaves.

WEEK 52

GRATITUDE FOR CHOICE

EVERY ARTIST DIPS HER BRUSH INTO HER OWN SOUL, AND PAINTS HER OWN TRUTH INTO HER PICTURES. —HENRY WARD BEECHER

Over the past fifty-two weeks, you've had many opportunities to experience your creative voice in a variety of mediums. You've learned how energy is something we can transform. It doesn't matter what we use our creativity for or how we use it—it matters *that* we use it.

Be grateful for your own power to decide. You know the answers. We all have detours in life, and a part of us has to accept that we can't control the outcome of things that happen to us.

On the other hand, we have to actively choose to follow a detour, and make something from it. So, this week, here's an exercise to help you be grateful for your own power to choose.

For each of these listed prompts, choose a different creative way to express what it evokes. I recommend a mix of journaling, drawing, painting, and photography.

1. The view out your window.

2. The current weather outside.

3. Your physical appearance.

4. Your room and house.

5. The home of one of your friends.

6. Someplace you've worked.

7. The street where you live.

10. Someplace you have traveled.

11. A plant or animal that you can see right now.

12. The favorite place that you have been to today.

13. The last meal you've eaten or your favorite food.

14. Your parents or grandparents.

15. Your go-to place to relax.

16. An animal or plant that you can go look at right now.

17. The smell of your pillow.

Did these prompts spark memories? Longings? Images? Creativity can help us make decisions or find the next step on our journey. And often, one creative act leads into another. Perhaps the smell of your pillow reminded you of warm cinnamon and inspired you to brew a cinnamon tea and now you are inspired to call a friend and go out for tea. Or maybe you are inspired to lie down right now and take a nap on your favorite pillow. You've traveled a long way. It's your choice.

Takeaways: Giving Back

LET US BE GRATEFUL TO PEOPLE WHO MAKE US HAPPY; THEY ARE THE CHARMING GARDENERS WHO MAKE OUR SOULS BLOSSOM.
—MARCEL PROUST

How can gratitude help us? When you know what you're grateful for, you know what your values are. Your values act like arrows telling you what direction you need to take on your road. Gratitude makes us go inward and also connects us to what's around us, allowing us to find more happiness in the small moments so that we can feel centered in the big moments. Take time every day to share your gratitude—it will lead to improved physical, emotional, and social well-being for yourself and others.

As we wind down this section, reflect on the ways that you can show your gratitude and appreciation to others. Think about the people who comprise your personal support system and brainstorm ways to give back to them. You might want to send them a thank-you note or put into practice the lessons they have taught you by performing a random act of kindness, mentoring a student, helping at an assisted living home, or just being available.

The biggest way to show gratitude is to share your heart with the world. Continue to create and put your work out there and let others

know what you've learned. Verbalize to the people in your life why they matter to you. Bake cookies and bring them to where you work, or treat someone to tea. Embracing your newfound creativity gives you wonderful ways to show your gratitude for being alive, and gratitude is contagious. Be a creativity and gratitude role model for others.

Commit to three acts of gratitude by writing them below.

1. _____

2. _____

3. _____

Flowers I collected on my journey:

afterword

L ife doesn't always go according to our plans, but that is the delicious part of being alive. Transforming detours—or any adversity—into adventure through creativity, story, wonder, and play has guided me through my life-threatening illness and the curves in the road that followed. I hope completing this workbook shows you that no matter where your life flows, you can harness your powers of resilience to pave a joy-filled path. It takes time to create joy and resilience, and you might find yourself going back to certain exercises again and again even after the fifty-two weeks are over. I certainly do. Sometimes revisiting old ideas can bring new ideas to life, because ourselves, our environments, and our circumstances are constantly changing. So open the book and flip to a random week. You never know what you may discover.

The wonderful part about creativity, inspiration, and gratitude is that you can find them anytime, anywhere, at any place. Every sensation I feel and every breath I inhale brings an image to my mind that fills me with giddy excitement. I find inspiration in everyday

miracles, and my first impulse is to create something with them. When I do, I feel aligned with the universe—like something larger is moving through me. I feel the limitless expanse of sky above me, my feet grounded in the earth, and my heart pulled between the two extremes.

I am an artist because that is how I feel like I belong; being an artist allows me to share my passion with others and receive inspiration from everything around me. I am an artist because I couldn't imagine any other way of connecting with my world, with myself, and with my passions. I wake up every morning with a drive to create. Coming down to my art studio every morning, I am reminded to go with the mess-ups, the hiccups, the slips of the hand, and the dried-up tubes of paint. For me, there is no such thing as a calculated, strategized painting. Art is being willing to see things differently and to love what you see. Sometimes, it's the dents in our canvases that make lasting imprints we'll cherish and remember with gratitude for the rest of our lives.

My question for you is, why not be an artist? Creativity as a mind-set literally saved my life—it allowed me to reimagine what was in front of me, to find gifts of resilience in pain and loss. By now, you have the tools you need to harness your own creative powers and turn obstacles into opportunities. Through transforming the aftermath of trauma, pain, or the unexpected into art, we create our own unique

masterpieces and cultivate bold, new identities that are uniquely ours. Yet, these individual journeys draw us together. By sharing our stories, we become empowered, inspired, and gain the confidence to become travel partners for others on their detours. After all, traveling is always less scary when we're not alone.

acknowledgments

Many thanks to creativity—the energy we *all* possess; to Apollo Publishers for their work in helping me bring this book to fruition; my four skills of resilience which have gotten me to this point and keep me going; to Matt, Adam, and Jeff, for their creativity in every aspect—laughter, music, conversation, and more; to my parents, for their love and unwavering support; and to the flowers that have guided my path—without them, this book would not be possible. Thanks to Leona F., Jeanine E., David F., Yokko, Elly D., Josh R., and the wonderfully supportive communities of Hampshire College, Goddard MFAIA, Community World Project, Tectonic Theater Project, and the Eugene O'Neill Theater Center. To Grandma Hannah and Grandpa Irving, whose spirits I feel in every button I sew or fabric I touch, thank you. If there are any living beings I need to thank most, it is the trees. You were always there before, after, and during, and I hope to continue to honor you and your wondrous community of nature through creativity and gratitude.

about the author

Amy Oestreicher is a multidisciplinary creator who overcame a decade of trauma to become a sought-after teaching artist, author, international keynote speaker, RAINN representative, PTSD specialist, and advocate for people with disabilities. Amy's multimedia creations have been showcased in galleries in Massachusetts, Connecticut, Chicago, San Diego, and New York. She is also an Audie award-nominated playwright whose one-woman autobiographical musical, *Gutless & Grateful*, has toured over two hundred venues since its debut in 2012. Her writing has been published in the *Washington Post*, *Glamour*, and *Seventeen* magazine, and her memoir, *My Beautiful Detour: An Unthinkable Journey from Gutless to Grateful*, was published in 2019. Amy is the founder of the campaign "LoveMyDetour," which is used for seminars, workshops, curriculums, books, music, and performances and is part of the National Initiative for Arts and Health in the Military. Amy is currently a candidate for a master of fine arts degree from Goddard College and a master's degree in puppet arts at the University of Connecticut. She lives in Westport, Connecticut.

Opposite: *Dancing Girl*

Free doodling

Free writing

Free doodling